IMAGES
of America

PORTAGE LAKES

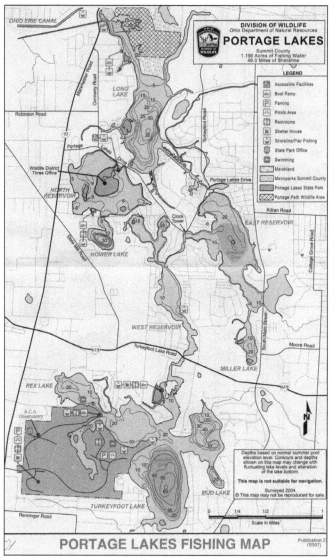

PORTAGE LAKES FISHING MAP

Ohio Department of Natural Resources Division of Wildlife Publication 270 shows the many lakes and waterways known as Portage Lakes. This Portage Lakes Fishing Map assists anglers with topography, as well as boat ramps, parking, picnic, and fishing areas. Portage Lakes in Summit County Ohio includes 1,190 acres of fishing water and 46 miles of shoreline. (Courtesy of the Ohio Department of Natural Resource, Division of Wildlife.)

ON THE COVER: In 1998, Portage Lakes celebrated its 23rd Antique and Classic Boat Show. Shown in this flyby are, from front to back, Eric West in his 1928 thirty-foot Hacker Craft Triple Cockpit Dolphin named *Gad-A-Bout*, the late Dr. Ben Gill in his 1960 eighteen-foot Chris Craft Continental called *Lady of the Lakes*, Scott Shookman in a 1956 seventeen-foot Chris Craft Sportsman he calls the *Stroller*, John Vorhies in his 1939 twenty-two-foot Chris Craft Triple Cockpit Custom Runabout named *Sashay*, Byron Kruger and Chuck Farlin in Farlin's 1953 seventeen-foot Chris Craft Sportsman, Denny Revlock in his 1955 seventeen-foot Chris Craft Sportsman named *Somewhere in Time*, and Noel Drack in a 1954 eighteen-foot Chris Craft Riviera named *Meredith*. (Courtesy of Bill Hunter.)

IMAGES
of America

PORTAGE LAKES

Carolyn Vogenitz

ARCADIA
PUBLISHING

Published by Arcadia Publishing
Charleston, South Carolina

Library of Congress Control Number: 2011941158

For all general information, please contact Arcadia Publishing:
Telephone 843-853-2070
Fax 843-853-0044
E-mail sales@arcadiapublishing.com
For customer service and orders:
Toll-Free 1-888-313-2665

Visit us on the Internet at www.arcadiapublishing.com

CONTENTS

ACKNOWLEDGMENTS

A book of this kind would not be possible without the cooperation of longtime residents, former publications, and history aficionados, as well as the desire to legitimize tales from the past. Thank-yous go to the many individuals who shared family photograph albums and stories of yesteryear. A special thanks is extended to R.C. Norris, the local historian whose insatiable appetite for the past moved this project forward. Thanks also go to Mary Miller and Walt Stashkiw for their red proofreader pens that kept us on track in the area of content and style. And a thank-you goes to Walt for the epilogue.

Many thanks are given to Laurie Kieffer, Rose Ann and Carl Clark, Dorothy Steele, Larry Hunter, Debbie Hensley, Earl Gessman, Linda Domico, Cyrus Thornton, Mary Antenora, Ken Patterson, Mary Kay Walker, Shirley Chuchu, Ken Gerstenslager, Pam Wayland, Brenda Patterson, Harry Welch, the Doug Hull family, Don Aldridge, Joe VanDevere, Glen and Georgia Sheets, Bev and Tom Fry, Bill Hunter, Perry Surgon, Jane Kepler Gerstenslager, Mary and Jim Miller, Todd and Sylvia Johnson, Neatzie Samples, Alan Giles, Lew Roberts, Laurie Norris, Karl Brothers, Greg Morgan, Dave Calderone, Susan Balmert, Erica Whitmer, David Fielder, Theresa Dunn, Marion Warner, Leianne Neff, Mary Plazo, Eleanor Stroup, Jim Miller, John Riddle, Ron Kotch, Randy Clark, Tom Longworth, Eileen Rex Snider, Frank Weaver, Jean Provence, Jean Vossberg, Mary Mozingo, Patty Hetrick, Sandy Walker, Winston Anderson, Barb Russell, and Bob Ashley.

A thank-you goes to each of the following organizations for supporting this project and sharing photographs and information: the local churches; Purple Martin Association, Dragon Dream Team, Portage Lakes Rowing Association, Coventry Local Schools, Coventry Fire Department, Green Fire Department, New Franklin Fire Department, Akron Yacht Club, Goodyear Yachting and Boating Association, Portage Lakes State Park, Turkeyfoot Island Club, Portage Lakes State Park, Summit County Historical Society, Portage Lakes Historical Society, Summit County Public Library, and the *Akron Beacon Journal*.

Additional information about Portage Lakes can be found in the following *Roto* issues of the *Akron Beacon Journal*: June 1953, May 1954, May 1955, March 1956, May 1957, June 1958, May 1959, January 1960, May 1962, July 1972, May 1976, July 1976, August 1982, June 1984, January 1987, June 1987, July 1993, and September 2000.

Unless otherwise noted, all images are from the author's personal collection.

INTRODUCTION

Portage Lakes can easily be divided into five historical eras to assist understanding how the lakes came to be today. The first examined is the Indian Era, when the land was primarily used for hunting, fishing, and traveling the streams by way of dugout canoe.

Several glaciers covered this part of the continent thousands of years ago. As the ice melted and the glaciers advanced and receded, enormous deposits of sand, gravel, and clay were left behind. Glacial impact left the area with steep hills and ravines and carved out the Great Lakes. As early as the 1600s, Native Americans from the East were being pushed westward by the white man. Local tribes, or "nations" as they preferred to be called, were the Miami, Wyandotte, Chippewa, Ottawa, Shawnee, Mingo, and Delaware.

Major paths used by the Indians later became roadways for white settlers. One of the important paths was the Mahoning Trail. Its eastern end followed the Continental Divide from Fort Pitt, later called Pittsburgh, entering what became Summit County just north of Tallmadge. The western end of that trail was known as the Watershed Trail, exiting Summit County north of what is now Copley.

North–south routes included the Muskingum Trail and the Cuyahoga War Trail that joined near what became Wadsworth Road. The Cuyahoga and Tuscarawas Rivers were of utmost importance in traveling through this part of the territory. In order to travel from one river to the other, it was necessary to portage eight miles over rugged terrain. Recorded on the earliest maps, Portage Path ran from about five miles north of what is now Akron to the Copley Road area. It continued south to a landing on the Tuscarawas River just north of Long Lake.

Ohio became the 17th state to join the Union on February 19, 1803. With the official declaration came the Farming and Coal Mining Era. Once the "West" was established, land developers saw the advantage of getting involved in acquiring this land. A group of speculators calling themselves the Connecticut Land Company purchased three million acres for $1.2 million. Surveyors divided it into 129 townships, with each township containing 16,000 acres.

Daniel Haines was the first white settler to move to Coventry Township. Other pioneers, including coopers, sawmill operators, carpenters, butchers, coal miners, and of course farmers, soon followed. The soil was rich and crops were plentiful. Coal from the numerous mines in Canal Fulton, Clinton, and Springfield Township was piled high. But a quick method to transport products to market in the East was badly needed.

The Ohio Erie Canal opened for business on July 4, 1827. Canals need an adequate water supply; therefore, low areas were cleared for impoundments and dams. Portage Lakes has four reservoirs and several impounded lakes. East and West Reservoirs were created in 1839 to supply water for the Pennsylvania and Ohio Canal. North Reservoir was built in 1906, when more water was needed for the rapidly growing industrial businesses in Akron. In 1936, Nimisila Reservoir was constructed as part of the WPA (Works Progress Administration) program. In addition to the four Portage Lakes reservoirs, the Tuscarawas Diversion Dam east of South Main Street was

built in 1956. The lake furnishes water for the north golf course at Firestone Country Club as well as Akron's factories.

On Sunday, March 23, 1913, an icy rain began to fall. The ground was frozen and could not absorb the water that poured down over the next three days. Historical records indicate that the Little Cuyahoga River flooded Case Avenue and the lower floors of the Goodyear Tire and Rubber Company. At approximately midnight on March 24, the East Reservoir dike at Portage Lakes gave way. In order to save the city's businesses, the canal locks in downtown Akron were dynamited. Perhaps that triggered the end of canal boat days—however, there was a new mode of transportation on the horizon. The fast-moving, cinder-throwing railway engines had come to Ohio.

Toward the end of the 1800s, hotels, restaurants, and dance halls began to appear in the Portage Lakes area. The Summer Resort Era brought visitors by wagon, jitney, and water launch. Young's Hotel, Melinger's Hotel, Albertson's Inn, Kepler's Hotel and Landing, Crook's Hotel, and Hackett's Edgewater Inn provided entertainment, lodging, and good food. Many of the hotel owners built small cottages that were available to rent by the week or entire summer. In addition, cottage-sized lots, 40 feet wide and 70 feet long, could be purchased for approximately $300. At the end of the summer season, cottages were boarded up until the following spring.

World War I ended in 1918. By 1924, America had coast-to-coast radio. By 1929, twenty-three million Americans owned $290 Ford Model T automobiles. Women bobbed their hair, dance marathons were the craze, and silent motion pictures were shown in theaters. Times were good! But then the stock market crashed. Instability and financial loss, tagged the Great Depression, swept the nation.

The 18th Amendment to the US Constitution in 1919 prohibited the manufacturing, sale, or transportation of intoxicating liquors; Prohibition lasted from 1920 to 1933. During that time, bootleggers built and operated liquor-producing stills. Moonshine was readily available, and at one time it was estimated that there were 1,500 bootleggers doing business in the Akron area. Portage Point Boulevard in Portage Lakes was known as "Whiskey Alley," where nearly every household participated in some type of manufacturing or sale of home brew.

The Bedroom Community Era was ushered in at the end of World War II when servicemen returned home and manufacturing peeked. The baby boom was occurring nationwide, and not enough housing was available. Portage Lakes was dotted with summer cottages, and winterizing the small structures proved to be the answer for many young families.

Something else was also happening in the lakes that gave the community a reputation of being outside the law. During Prohibition, saloons, bars, and taverns sprang up on nearly every corner or crossroads. It was estimated there were no less that 33 roadhouses in southern Summit County, and many of them were at the lakes. These establishments attracted unruly crowds who enjoyed drinking and gambling. Speakeasies and slot machines were the norm.

During daylight hours, visitors continued to flock to the lakes. Sandy Beach Amusement Park on South Main Street boasted mechanical rides, a large dance hall, and an outdoor boxing ring. Local marinas sold and serviced boats and motors. Canoes could be rented, and boat races attracted hundreds of spectators.

The last period to be examined is the Transition Era, in which Portage Lakes morphed from a less desirable area to one of respectability. There are approximately 2,000 waterfront homes, and cottages are being replaced with million-dollar dwellings. Census figures from 2010 indicate that 51,000 people live in Coventry Township and the cities of Green and New Franklin. The Division of Parks and Recreation of Ohio considers Portage Lakes the state's most used inland waterway for recreational sports. No longer agrarian in nature, the community is undergoing transition.

One

BEFORE THE WHITE MAN

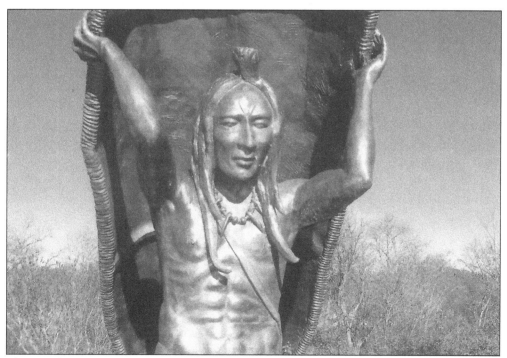

The Cuyahoga and Tuscarawas Rivers are only eight miles apart and were connected by an age-old path, or portage, used by the Native Americans. Going as far a possible by water, they would then carry their possessions overland the eight-mile distance to reach the adjoining river. The worn path through what is now Summit County was known as the Portage Path. (Courtesy of Randy Clark.)

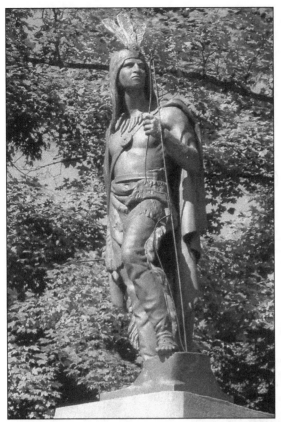

Although the Portage Lakes area was not a battle zone, an aggressive Delaware Indian by the name of Konieschquanoheel, a leader of the Wolf Tribe, lived in a village along the south shore of Nesmith Lake. Known as Chief Hopocan, or Captain Pipe, his colorful history is of interest. He distrusted the white man and was constantly urging his nation to war. Historians give him credit for avenging the deaths of the Moravians at Gnadenhutten, and when the Revolutionary War began Pipe convinced a band of Indians to fight alongside the British.

An axe head and Indian points were found by Hank Grimm while he was tilling his garden on Willowview Drive over a period of time in the late 1940s and early 1950s. There was good hunting in the area that was generally considered to be neutral territory by many Native American tribes; most did not believe in owning property or putting up fences. When the early settlers began to arrive, the natives were gradually pushed westward.

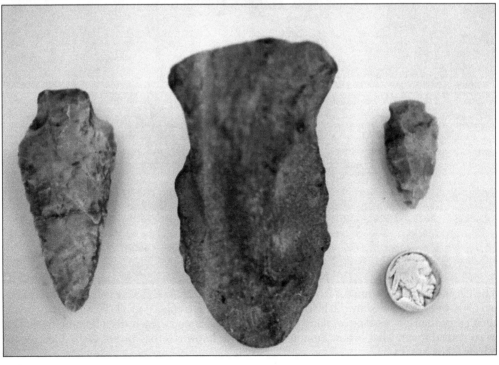

William Yeck, a Dayton, Ohio, philanthropist who grew up in the Akron area, felt that the portage should be memorialized. In 2001, with $500,000 from the William and Dorothy Yeck Family Foundation, he took the initiative to mark the trail. The author stands next of one of two eight-foot-tall statues. There are 31 bronze arrowhead-shaped markers designating where the Indians portaged through what is now Akron.

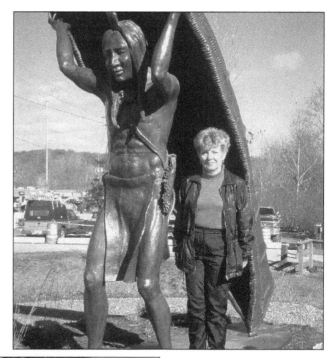

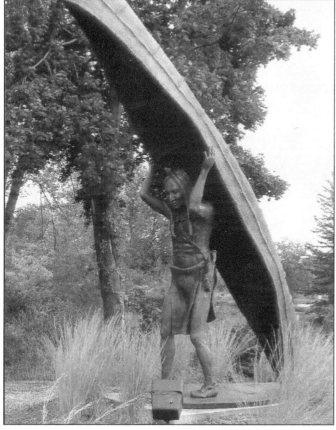

Just north of Long Lake in Coventry Township, Native Americans were able to drop their canoes into the water of the Tuscarawas River after portaging through the rough terrain of what would become Akron. A bronze statue stands at the northern end of the portage next to the Cuyahoga River at Merriman Road and North Portage Path, while the southern terminus is marked by an identical statue on Manchester Road.

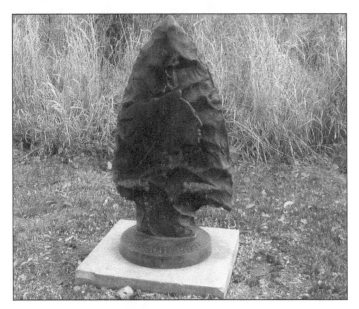

A series of 31 bronze arrowhead markers designates the path Indians took through the hilly landscape carrying their belongings. The portage from north to south runs through Sand Run Metropolitan Park, crosses Copley Road, and continues through Perkins Park. It intersects Euclid Avenue and heads towards Wooster Avenue and Manchester Road. The trail then crosses Waterloo Road and terminates near Manchester Road and Carnegie Avenue.

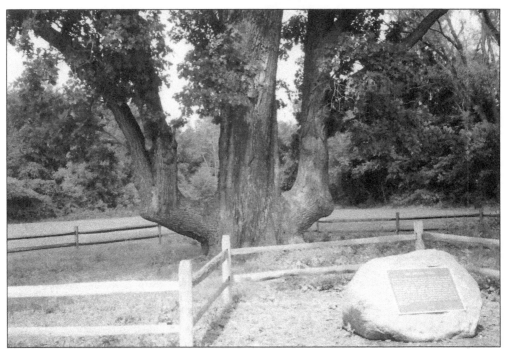

The old Bur Oak referred to as the Signal Tree since the early 1800s is approximately 300 years old. It was customary for Native Americans to bend and shape trees to mark paths that would serve as natural maps to those traveling in uncharted lands. This oak is located in the Cascade Valley Metro Park in Akron, Ohio, and probably indicated that a portage lay ahead.

Chief Hopocan of Barberton stands at the intersection of Norton Avenue and Wooster Road in New Portage Park. Erected in 1911 to commemorate the Indians and the early settlers of the village of New Portage, the 19th-century statue of a Native American was made and sold nationwide by J.L. Mott Iron Works. The monument was in a state of disrepair when the Barberton Kiwanis raised $9,000 in 2001 to refurbish it.

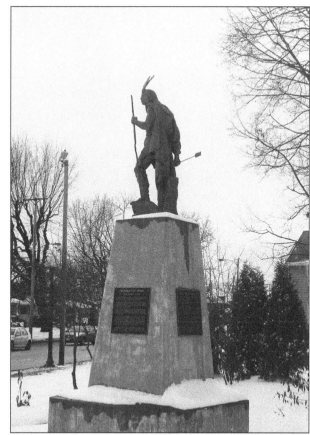

The Delaware Indians, also known as the Lenni Lenape, belonged to the Algonquin linguistic family and had numerous villages throughout the area, including Portage Lakes. It is believed that a young girl by the name of Mary Campbell was kidnapped in Pennsylvania by some Delaware Indians and held temporarily in this cave until a permanent camp was ready. This massive cliff is located in Gorge Park in Cuyahoga Falls, Ohio.

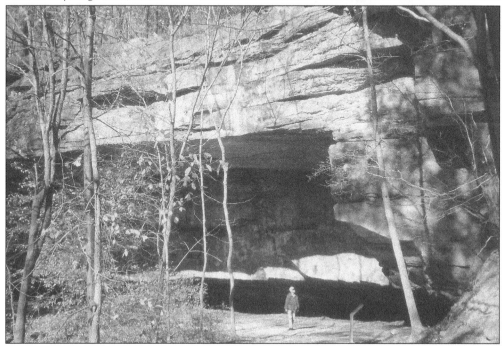

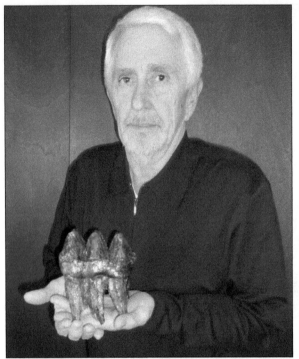

Ken Gerstenslager was a typical 13-year-old kid hanging around watching the dredging of the southern portion of Turkeyfoot Lake. As the muck was pulled from the water, Ken and his buddies would examine it, discovering all kinds of things. Ken was the lucky one to find what looked like a tooth—in fact, it was a tooth. Archeologists identified it as a molar from a bull mastodon that lived nearly 25,000 years ago.

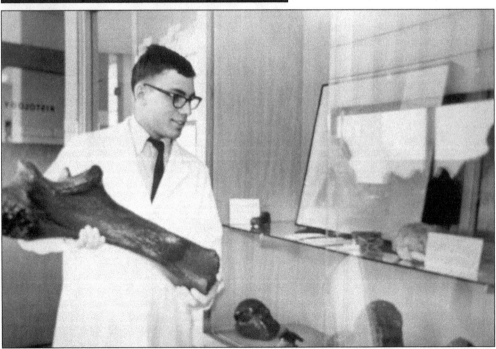

On a warm June morning in 1965, the suction dredge working Turkeyfoot Lake pulled a mastodon bone from the muck. A relative of the modern-day elephant, this extinct mammal was shorter, stockier, and covered with hair. Experts agree that below the lake bottom, the bones were protected from bacteria that would have caused decay. The Turkeyfoot mastodon bones are stored in the archives at the University of Akron.

Two

EARLY RESIDENTS

The first non-Indian residents came to the Portage Lakes region as farmers, coal miners, millers, and hotel and restaurant operators. As early as the late 1700s, a few Native Americans were still in the area, but they were gradually moving westward. Discovery of the many lakes and available coal resources attracted entrepreneurs who had the foresight to claim the rugged territory.

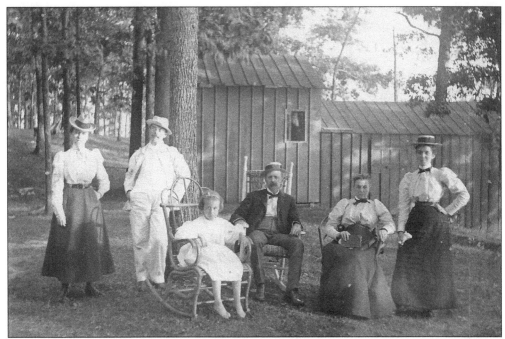

These Turkeyfoot Island residents pose for the camera in the late 1890s. They are, from left to right, Mrs. and Mr. Kempel, an unidentified child, Mr. and Mrs. Aaron Wagoner, and Maud Wagoner. In a pamphlet touting the benefits of the secluded location, Frank S. Lahm was quoted as saying, "Happiness lives on an island." (Courtesy of Turkeyfoot Island Club.)

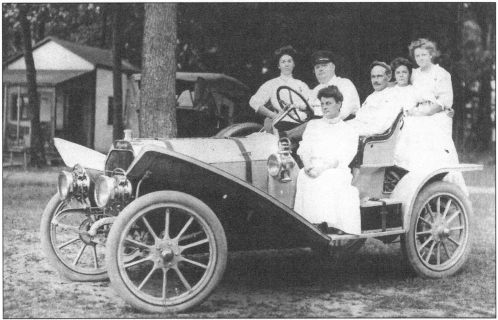

Gus Burkhardt, president of the Burkhardt Brewing Company in Akron, Ohio, is at the wheel of his 1906 Oldsmobile Red Cloud near a small cottage on Turkeyfoot Island. The open-air automobile with its large tires made the trip from Akron more comfortable than a horse and buggy even though dirt roads were the norm of that era. (Courtesy of Turkeyfoot Island Club.)

In his younger days, Frank S. Lahm and his friend Charles Pendleton visited Chippewa and Congress Lakes and eventually discovered the isolated Turkeyfoot Lake in 1876. Expecting the railroad to come through, bringing guests to the lake, Lahm purchased the property for $1,700 in 1877. He constructed a large clubhouse and allowed 24 cottages to be built on the island. (Courtesy of Turkeyfoot Island Club.)

Frank P. Lahm, son of Frank S., shared his love of ballooning with his father. After graduating from West Point in the early 1900s, Frank P. entered international balloon racing. He was also taught to fly airplanes by the famous Wright brothers. Frank P. was named as the commanding general of the Gulf Coast Air Corps Training Center and became the Army's first certified pilot in 1909. (Courtesy of Turkeyfoot Island Club.)

Dapper Turkeyfoot Island ladies and gents gather at the steps of the second house from the west end of the island in 1909. Cottages built on the island proved to be a perfect escape from city life for those who could afford to reside there. However, entrepreneur Frank S. Lahm established strict rules concerning maintenance of the island retreat. (Courtesy of David Fielder.)

These people are bundled up for an afternoon ride on a roadway that could turn to mud with the onset of rain. Congress designated hundreds of thousands of miles of land in the West for development. A parcel of land 120 miles long, located between the 41st parallel and the shores of Lake Erie, is recognized today as the Western Reserve. (Courtesy of Turkeyfoot Island Club.)

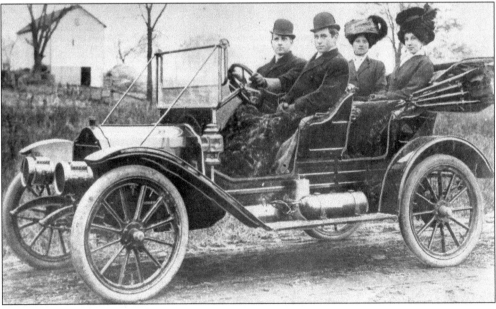

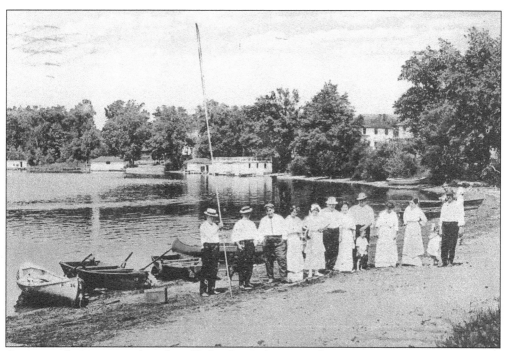

A variety of stories exist about how Turkeyfoot Lake received its name. Historical lore claims its shape is similar to the shape of a turkey's foot, while other tales cite an Indian known as Turkeyfoot. No one knows for sure. What is known is that the west side of Turkeyfoot Lake was the Canton, Ohio, side, and the east side was settled by Massillon, Ohio, folks.

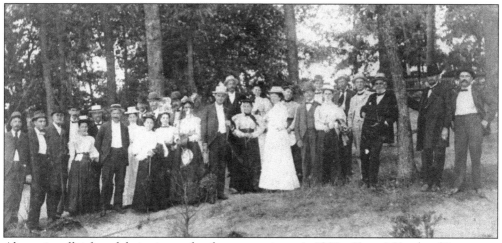

Akron city officials and their wives gather for a group picture in 1900 at Young's Hotel and Restaurant on Nesmith Lake. Summit County historical records include names that were responsible for success of the bustling little city: Button, Buchtel, Young, Rowley, Paige, Wilson, Stipe, Manderbach, Newbar, Hoye, Payne, Parshall, Callahan, Crisp, and Baker. (Courtesy of R.C. Norris.)

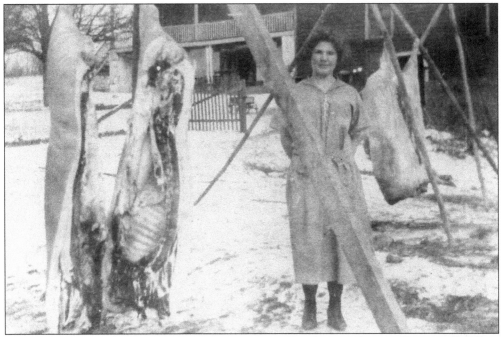

A grand farmhouse was built in 1844 on 500 acres of land at South Main Street and Killian Road. By the early 1900s, Cyrus and Lucinda Miller owned the farm but leased it to Daniel and Armanda Enlow. Daniel peddled milk and eggs to customers in the Portage Lakes area from 1908 to 1923. Armanda stands near hanging carcasses on a cold winter day in 1919. (Courtesy of Cyrus Thornton.)

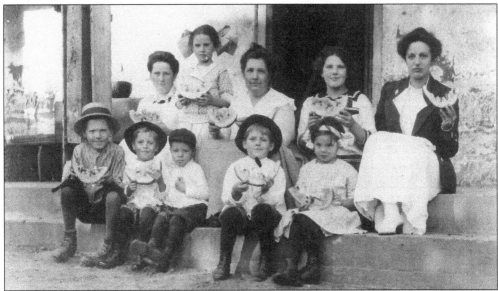

On a warm summer day in the early 1900s, ladies and children are enjoying watermelon on the Enlow farm, presently the location of the Interval Brotherhood Home, at South Main Street and Killian Road. From left to right are (first row) Alvin Enlow, Lawrence Enlow, ? Renninger, Ernest Enlow, and ? Renninger; (second row) Faye Climbs Renninger, ? Renninger, Armanda Enlow, Martha Enlow, and Rosa Broadwater. (Courtesy of Cyrus Thornton.)

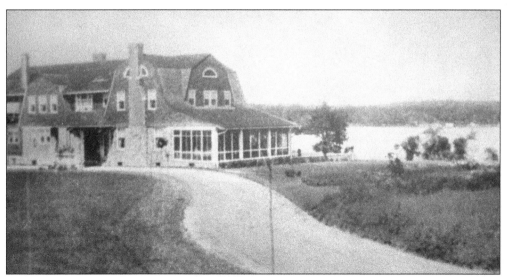

Frank Hibbard Mason was born in New Hampshire in 1852. He became vice chairman of the board of directors at the B.F. Goodrich Company in Akron, Ohio. The Mason family owned 746 acres, known as the Brighton Farm, in Franklin Township. The original house on the property (seen here) was destroyed by fire in 1909. It was replaced with a new brick mansion boasting a 30-foot-by-50-foot ballroom.

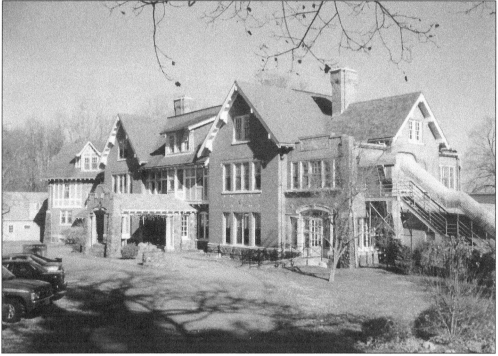

The ostentatious 43-room brick mansion located on the west bank of Turkeyfoot Lake was a grand place for entertaining. After a major fire on the property, Frank Hibbard Mason built the second Mason Manor between 1910 and 1912. Frank's will granted the residence to grandson John Gilbert Mason, who lived there until 1941. Over the years, the mansion fell into a state of disrepair and was eventually demolished.

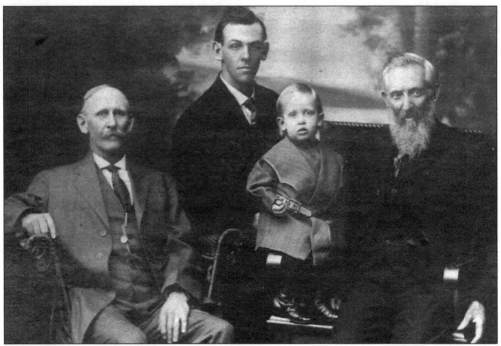

Bearded George Adam Rex bought one square mile of land, including Rex Lake, from his ancestor Jacob Rex, who came to the wilderness in the late 1700s and lived peacefully among the Native Americans. This early-1900s photograph includes, from left to right, Lewis Almond Rex, Claude Rex, young Leroy Rex, and George Adam. (Courtesy of Eileen Rex Snider.)

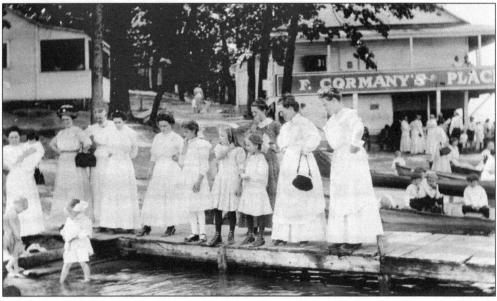

In 1830, several Cormany brothers walked from Center County, Pennsylvania, to the Portage Lakes area and acquired 640 acres of land. In 1851, one of the clan bought a farm bordering the western shore of Long Lake. In 1905, Frank Cormany inherited the farm and built a dance pavilion, grocery store, and swimming beach. Times were good, and visitors from all of northeast Ohio came to Cormany's Landing. (Courtesy of Summit County Historical Society.)

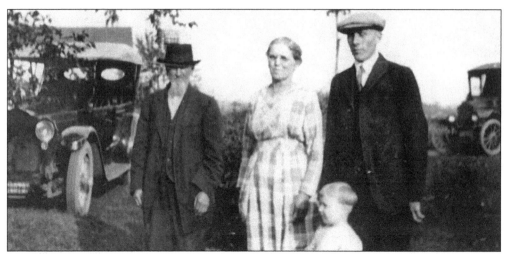

From left to right, Adam Kepler, Lucetta Kepler Krumroy (Adam's daughter), young Mildred Krumroy, and Otis Krumroy stand for a photograph taken on Kepler's farm in 1917. The farm was located on the south side of Turkeyfoot Lake. The Packard automobile on the left was owned by the president of Miller Rubber Company, William Pfeiffer, who was married to Carrie Kepler. The Model T truck belonged to Adam. (Courtesy of Karl Brothers.)

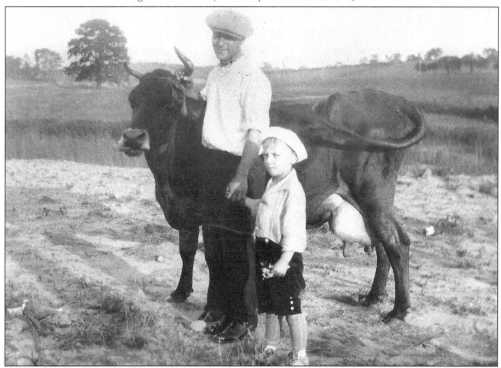

Young Cyrus Thornton stands with his father, Russell Allen Thornton, in the cow pasture in the early 1900s near what is now Waterloo Road and South Main Street. The farmland in the background eventually became Holy Cross Cemetery. Careful examination of the photograph reveals a pond (directly behind the cow) and a mausoleum (on the hill in the background). The rural community was dotted with farms and crossed by rutted dirt roads leading to the lakes. (Courtesy of Cyrus Thornton.)

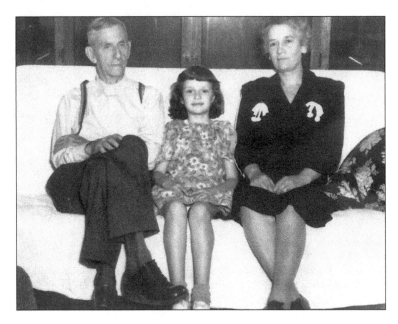

Nine-year-old Rose Ann Crooks sits between her father, Frank Crooks, and his second wife, Bernice Shafer Crooks, in 1947. Frank operated the Turkeyfoot Island Clubhouse from 1895 until he built his own hotel on Long Lake nine years later. Crooks Hotel joined others in the area run by Lewis Young and Johnny Groetz. (Courtesy of Rose Ann Crooks Clark.)

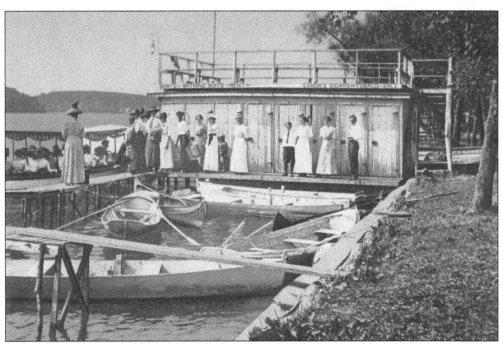

From 1910 through 1915, George Hackett operated Hackett's Edgewater Inn on the eastern shore of Turkeyfoot Lake. Registration records show that movie star Lillian Gish was a guest. Nephew Charles Hackett and his wife, Dora, actually managed the inn and traveled by horse and wagon to buy supplies for the establishment. Room and board, which included three meals a day, was $12 a week.

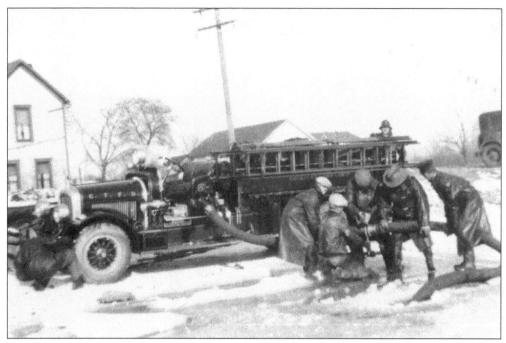

Wooden structures and lack of emergency equipment in the early 1900s meant that often structures burned to the ground. Throughout southern Summit County, the Coventry Fire Department volunteer squad was called to fight the flames. It borrowed a fire engine from Barberton in 1928 and pumped water from Portage Lakes in both winter and summer. The township was finally able to purchase its own fire engine in 1930.

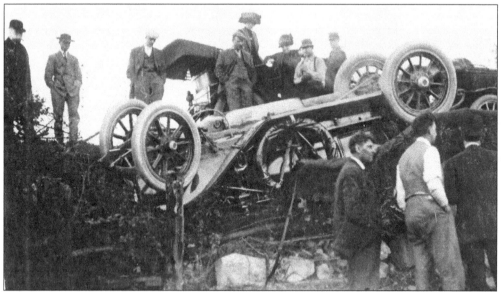

Frank Crooks (in white shirt to the lower right) was born in Massillon in 1871 and was one of the pioneers in the Portage Lakes restaurant/hotel business. He built his establishment on the south shore of Long Lake. Crooks was a successful businessman and probably had one of the first automobiles in the area. Unfortunately, he rolled his Ford on South Main Street in the early 1900s, seen here, but fortunately was not hurt. (Courtesy of Rose Ann Crooks Clark.)

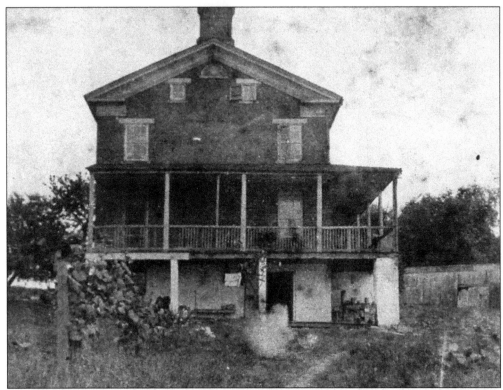

This farmland and house belonged to David and Manuel Thornton in the mid-1800s; the Interval Brotherhood Home now occupies the property. The history of this old homestead includes a period of time when the land was sold to the Society of Mount Carmel, and 15 to 20 Carmelite fathers lived at the monastery. For several years, farming and raising chickens was carried on extensively. (Courtesy of Interval Brotherhood Home.)

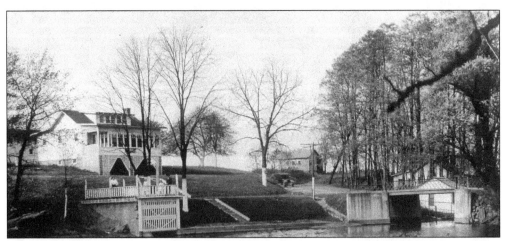

One of the newer houses on the Turkeyfoot Channel in the 1920s was the Dellenberger cottage. Harry and Mable Thornton Dellenberger built their home on what is now State Park Drive. The automobile in the photograph is traveling east on West Turkeyfoot Lake Road (Route 619). The building in the trees in the lower right is Dietz's Landing. (Courtesy of Cyrus Thornton.)

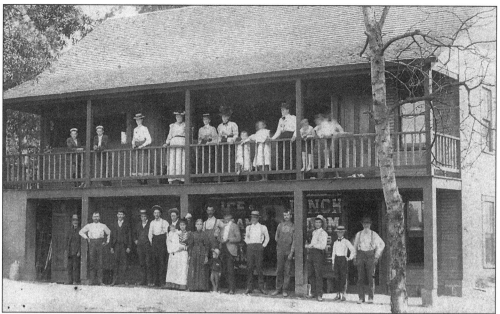

One of the very earliest pictures of Kepler's Hotel on the south side of Turkeyfoot Lake shows the building with only two floors. Built in the late 1800s, the hotel added a third floor at a later date. As was customary at the time, both men and women are wearing hats. Long dresses were the style of the day for the ladies. (Courtesy of Jane Kepler Gerstenslager.)

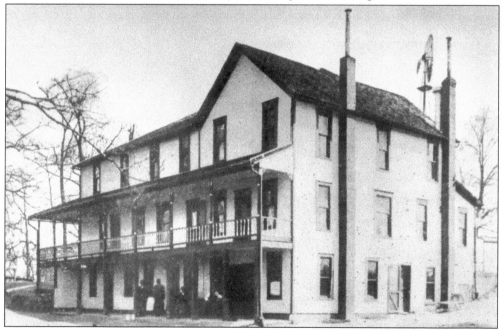

William Kepler built a hotel for coal miners working in local mines in the late 1800s. The building had several sleeping rooms and a rambling veranda where one could enjoy a satisfying smoke after the supper meal. Approximately 500 miners were employed in Coventry, Springfield, and Franklin Townships at one point. Crude railroads and even the Ohio Erie Canal helped get the coal to market.

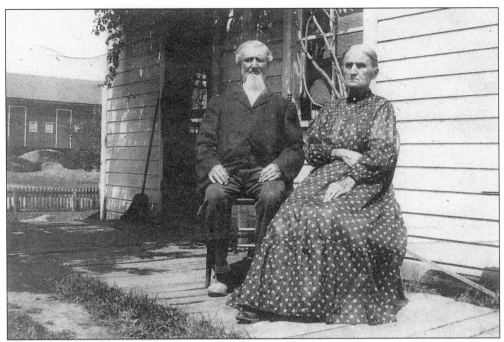

Adam and Mary Kepler sit for a photograph on their large farm in the Turkeyfoot Lake area. A turn-of-the-century map made under the direction of the superintendent of public works and the Ohio Canal Commission identifies major landholders: Adam owned 95 acres, Solomon Kepler owned the east shore of Mud Lake, and Ada Leighton owned 80 acres on Mud. (Courtesy of Ken Gerstenslager.)

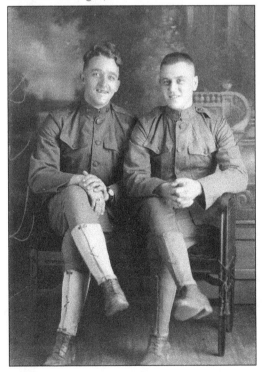

The Kepler family established roots in the Portage Lakes area when settlers arriving from the East were encouraging Native Americans to move westward. Records indicate that along with the Thornton, Brewster, Crouse, Granger, Haines, Allen, Renninger, Cormany, Warner, and Young families, the rolling hills were populated with hardworking men and women. Young Harry Kepler (right), with an unidentified companion, served in World War I. (Courtesy of Ken Gerstenslager.)

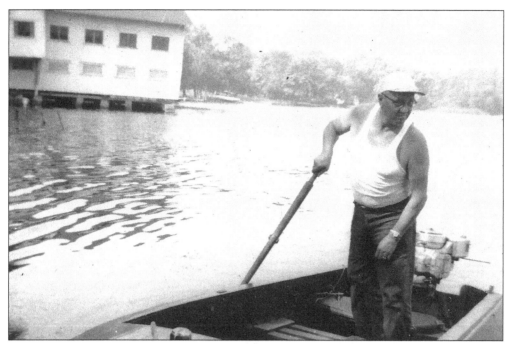

Harry Kepler guides his boat on the south shore of Turkeyfoot Lake in the late 1950s. Kepler's Dance Pavilion and Bath House in the background was constructed in 1921. Built out over the water, it was a romantic place to swing to the tunes of nationally known stars such as Guy Lombardo, Billy Grantham, and Jim Figley. (Courtesy of Ken Gerstenslager.)

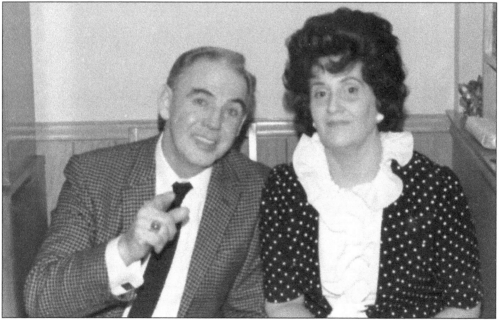

Ken and Jane Kepler Gerstenslager, now 90 and 88 years of age, are shown here in the mid-1980s. Longtime residents of the Portage Lakes area, Jane traces her roots to the early settlers who came to the region as farmers, miners, and hoteliers. She recalls the Prohibition days when illegal liquor flowed freely in this part of the country. (Courtesy of Jane Kepler Gerstenslager.)

This Tudor-style house was a wedding gift, built in the late 1920s, from Akron industrialist Frank Mason to his grandson Raymond and his bride, Zeletta. Henry B. Ball and Robert Fabbro owned the property before it was acquired by the State of Ohio in 1974. In 2010, the Department of Natural Resources deeded the 20-room mansion and 5.3 acres of land on the western shore of Turkeyfoot Lake to the City of New Franklin.

Members of the Summit Motor Boat Association, later called the Akron Yacht Club, prepare for the presentation of the traditional plaque to the outgoing commodore, Dr. W. F. Prim, in 1954. From left to right are 1954–1955 commodore Robert Shriver, Heddie Shriver, Willie Spencer, and 1955–1956 commodore Robert Spencer. Family memberships over the years have ranged in number from 70 to 125 at the club on South Main Street. (Courtesy of Akron Yacht Club.)

Three

CANALS, RESERVOIRS, AND LAKES

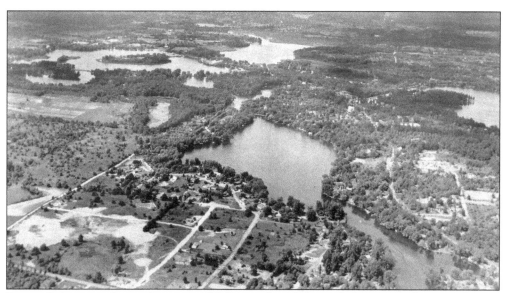

Portage Lakes is made up of many small lakes, as this 1947 aerial photograph shows. In the late 1700s, Moses Warren surveyed the area from north of the Cuyahoga River to a southern point on the Tuscarawas River. His field book reads, "I discovered a pond 80 chains long and 30 chains wide"; Warren was describing Long Lake. (Courtesy of *Akron Beacon Journal*.)

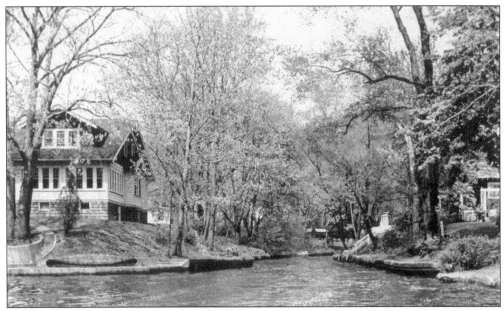

The west entrance to "Lovers Lane," more commonly referred to as the Iron Channel, has a history almost as extensive as the lakes themselves. The 1,500-foot-long, 50-foot-wide channel was constructed to connect East and West Reservoirs. The Department of Natural Resources, Division of Water, operates and maintains the hydraulic operations that keep the lakes from flooding. (Courtesy of *Akron Beacon Journal*.)

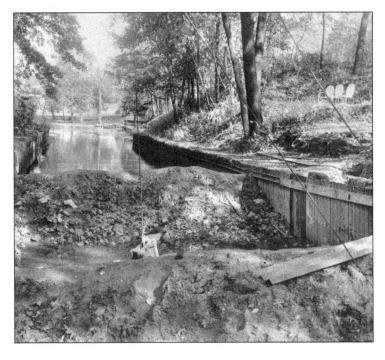

Seen here in 1966, the Iron Channel is undergoing yet another revision. These concrete abutments, remnants of an old gate or lock, are being removed so that more than one boat can go through at a time. The changes were supervised by the Department of Natural Resources, Division of Water. The Tuscarawas Watershed drains nearly 556 square miles in the northeastern four-county area. (Courtesy of *Akron Beacon Journal*.)

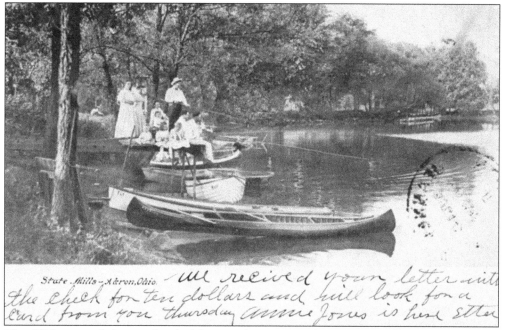

State Mills - Akron. Ohio. All recived your letter with the check for ten dollars and will look for a card from you thursday annie Jones is here Etter

This 1910 postcard shows a family fishing and enjoying a day at State Mills in Portage Lakes. Unlike 21st-century fashions, these ladies are outfitted in long white dresses that are probably extremely warm. State Mills acquired its name from the mill built by the State of Ohio in the 1840s at the north end of West Reservoir. (Courtesy of the Ruth Clinefelter Postcard Collection at SummitMemory.org.)

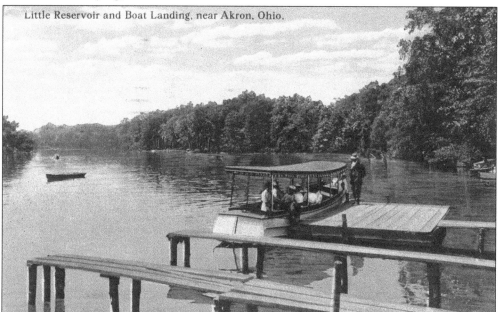

Little Reservoir and Boat Landing, near Akron, Ohio.

A launch landing on Little Reservoir (West Reservoir) in 1916 brings visitors to the lakes from the Summit Lake area in Akron, Ohio. The opportunity to spend a day in a restful, quiet area enticed city dwellers to the country. (Courtesy of the Ruth Clinefelter Postcard Collection at SummitMemory.org.)

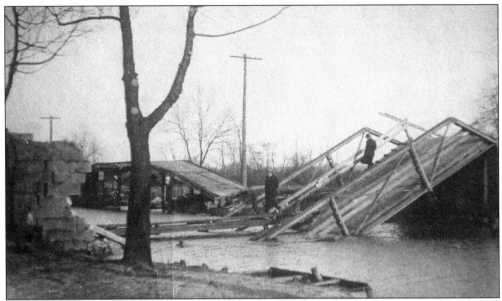

It rained for three days in March 1913, causing the dike at East Reservoir to break. This bridge on Manchester Road near Carnegie Avenue was destroyed as the water went cascading toward the city of Akron. To relieve the area of rising waters, a decision was made to dynamite the canal locks in downtown Akron. The locks were never rebuilt, signaling the end of canal transportation.

Viola and Bob Anderson ran Dusty's Landing for Viola's parents, the Willis Elmer Dustmans, who took over the fishing camp, owned by Lewis Young, in 1918. When R.C. Norris purchased the boarded-up property in 1984, there were 14 cottages in a state of disrepair and a cinder-block structure that had served as Anderson's headquarters. Seen here in the 1940s, notice the voting booth behind Dustman's truck. (Courtesy of R.C. Norris.)

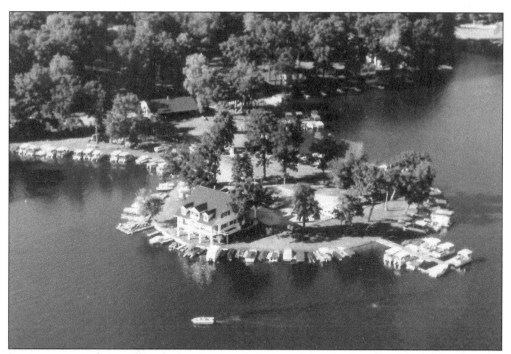

Jutting out into the north end of Turkeyfoot Lake is a peninsula that has changed hands many times over the last 200 years. Listed on the tax records of what is known as Dusty's Landing are Isaac Dissinger, John Benner, Col. David Thomas, Lewis Young, Frances Benner Snyder, Viola and Bob Anderson, and R.C. Norris. (Courtesy of Bruce Ford.)

Bob and Viola Anderson moved to Willis Elmer Dustman's fishing camp in 1918 to help Viola's aging parents run the establishment. Anderson's pickup is piled high with water plants harvested by the dredge seen in the background at what is known as Dusty's Landing. Bob was 93 years of age and Viola 86 when the estate was put up for auction in 1984. (Courtesy of R.C. Norris.)

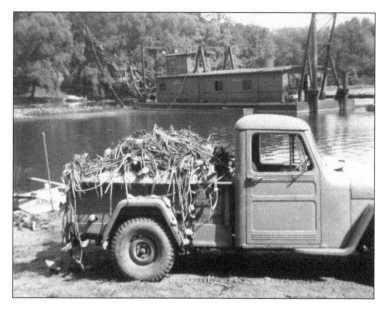

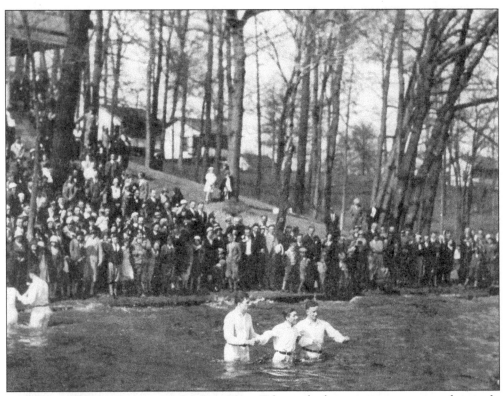

Fifty teeth-chattering converts were baptized in the chilly waters of Rex Lake in 1932 while a crowd of 3,000 friends and relatives watched. The Reverend Bill Denton, founder of the Furnace Street Mission as well as a daily radio program, immersed each individual during the outdoor baptismal service. (Courtesy of *Akron Beacon Journal*.)

Samuel Thornton inherited the plantation in Franklin Township in 1846 at 22 years of age. When he was 33, he moved his family to Akron to the 206-acre Buchtel farm near what is now Thornton Street. In early days, the large farmhouse on West Turkeyfoot Lake Road served as a stagecoach stop. Today, Turkeyfoot Golf Course and the Upper Deck are located on the former farm property.

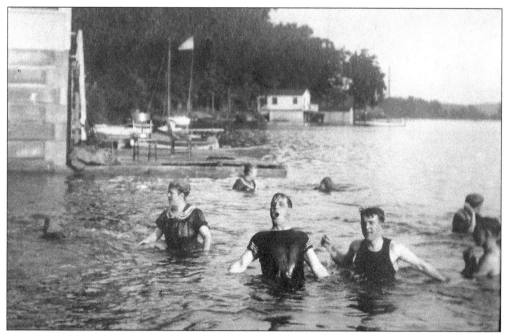

This swimmer in Turkeyfoot Lake in 1905 is probably shouting, "Ohh-ho, the water is cold!" Notice the swimming attire was a bit different in the early 1900s, as confirmed by the young folks in the water. A haven for sailors, the Portage Lake Yacht Club is housed in the lower level of the Turkeyfoot Island Club on Lahm Drive. (Courtesy of David Fielder.)

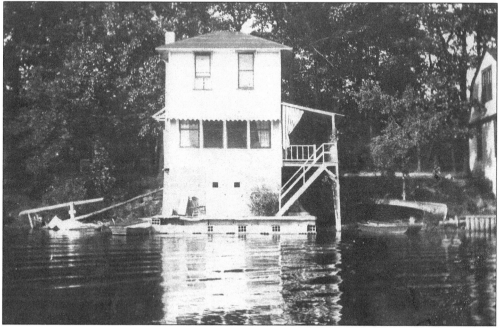

This summer cottage nestled among the trees on Turkeyfoot Island was typical of the private hideaways established by Frank S. Lahm in the first part of the 20th century. Nearly a half mile from the main road through fenced pasture fields, it was not an easy destination to reach by horse and buggy or the newfangled automobile. (Courtesy of David Fielder.)

Young Winston Anderson stands atop the inverted wooden boat with the support of cousin Madeline Baker McCarthy in the early 1940s on Boat Drive. From this position on the western side of East Reservoir, only a few houses can be seen across the lake. Lots were generally being sold for summer cottages, but the lakes area was still rural in the eyes of the city dweller. (Courtesy of Winston Anderson.)

A science book will define a "floating island" as a mass of floating aquatic plants, mud, and peat ranging in thickness from a few inches to several feet. It may stay in one place and then gradually begin to drift with the current. This mass of materials found in Portage Lakes in the 1950s was a phenomenon not seen in the area in the past. (Courtesy of *Akron Beacon Journal*.)

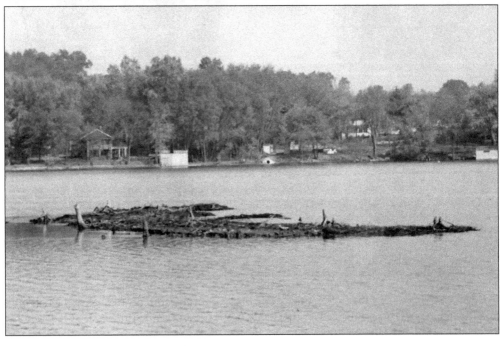

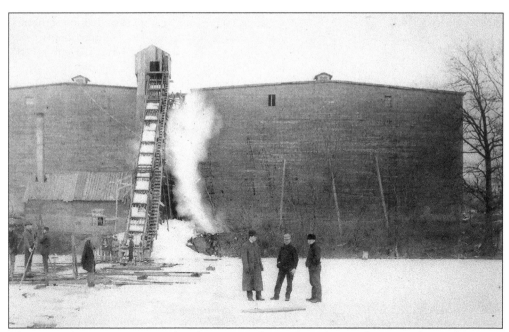

The steam-driven conveyor and icehouse were located on the northeastern shore of Cottage Grove Lake. Ice was harvested to be used year-round. In the early 1900s, the building burned to the ground. Old conveyor wooden pilings were discovered underwater in 1969 near what is now 146 Polonia Avenue. The photographer of this shot was H.F. Peck of Akron, Ohio. (Courtesy of Carl and Rose Ann Clark.)

Workers at Warner's Boat House take time from the chores at hand to watch ice-skaters on East Reservoir in the late 1940s. Northeast Ohio's bitterly cold winters generally cause the lakes to freeze for several weeks, and winter sports are enjoyed by kids of all ages. (Courtesy of Dorothy Peale Suit Steele.)

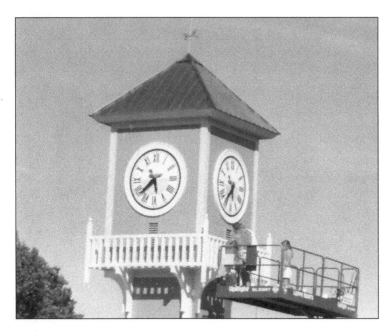

Located in southern Summit County, Ohio, Coventry Township is a community surrounded by lakes. Dedicated in 1999, the Coventry Clock Tower stands at the intersection of Portage Lakes Drive and South Turkeyfoot Road and serves as a historic landmark in the heart of Portage Lakes. On this warm summer day, workers adjust the mechanism on the clock.

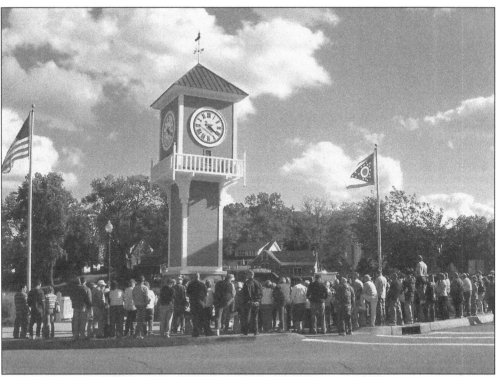

The dedication of the Ohio Historical Marker commemorating Coventry Township and Portage Lakes was held on October 1, 2006. The inscription includes information validating that Native Americans ceded land in 1785 to the United States under the Treaty of Fort McIntosh. It was not until 1840 that the land officially became part of Summit County. In 1806, Daniel Haines was the first resident to settle in Coventry Township.

In the early 1900s, it was decided that East and West Reservoirs could not furnish the needed water for the booming industry in Akron, Ohio. In 1907, steam shovels, teams of horses, and wagons moved tons of dirt to impound the water. A new road called Portage Lakes Drive was built across the dam, and Myers Island (in the foreground) became a state-operated fish hatchery. (Courtesy of *Akron Beacon Journal*.)

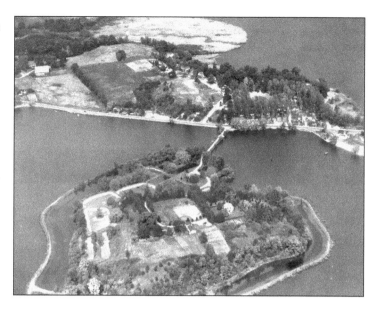

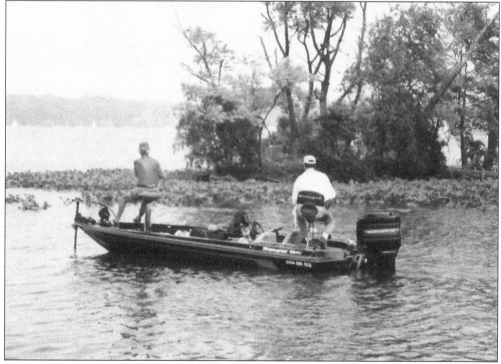

Always hoping to catch the "big one," fishermen use bait and boats of all types. Common game fish in Portage Lakes include largemouth bass, bluegill, pumpkinseed sunfish, redear sunfish, brown bullhead, common carp, black and white crappies, warmouth sunfish, saugeye, walleye, northern pike, muskellunge, tiger muskellunge, channel catfish, and chain pickerel. Aquatic vegetation in the lakes that can reach nuisance levels includes coontail, Eurasian watermillfoil, and curly-leaf pondweed.

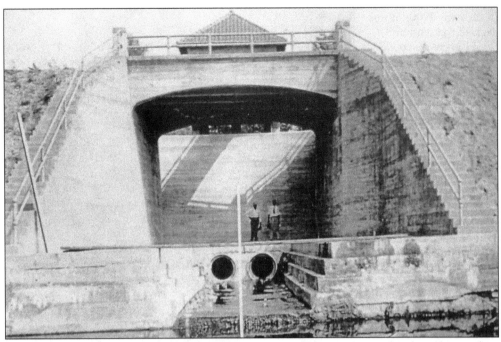

Floodwaters from East Reservoir tore a channel more than 250 feet wide when the earthen dike broke during the flood of 1913. This is the replacement dam on Portage Lakes Drive near North Turkeyfoot Road. The roof of the pump house can be seen beyond the protective rails at road level. Cars travel daily on Portage Lakes Drive, and work started in 2011 to shore up the ancient dam.

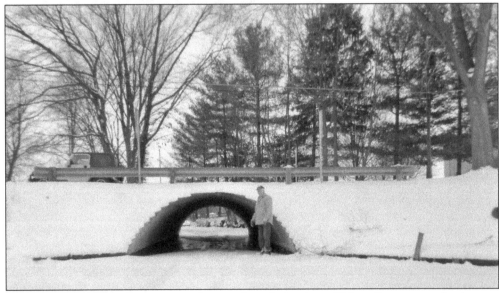

The developer of this allotment saved money by substituting a 15-foot-diameter steel culvert to span Rex Lake Channel. The result was the creation of the so-called "sewer pipe trip," an aquatic fun house. Shallow-draft boats with neophyte passengers doubted passage, and each skipper had a favorite yarn. R.C. Norris would say, "Hold on tight, there's a waterfall at tunnel's end that tosses the boat around." (Courtesy of R.C. Norris.)

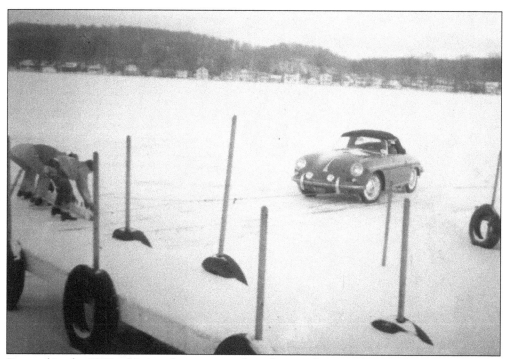

Pictured in the 1950s, this is a clever way to clear the ice of snow as long as the ice can support the weight of Barney Burnett's sports car. Ice-skaters ready the two-by-four, while Burnett waits for the backup signal from the men near the bank. Removing the blanket of snow will improve the surface for ice hockey. (Courtesy of Eleanor Stroup.)

The Department of Natural Resources, Division of Water, operates and maintains the Portage Lakes Dams, Nimisila Reservoir Dam, Tuscarawas Diversion Dam, and 10 miles of the Ohio and Erie Canal. In the fall of the year, the main lakes are lowered so homeowners can work on their seawalls. Here, men on Waterside Drive contemplate how to remove a large chunk of cement. (Courtesy of John Riddle.)

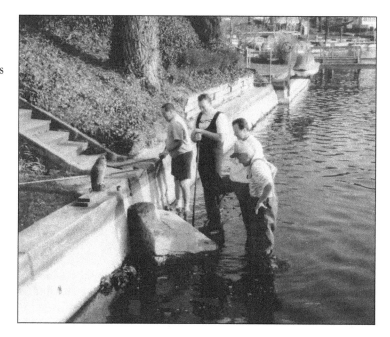

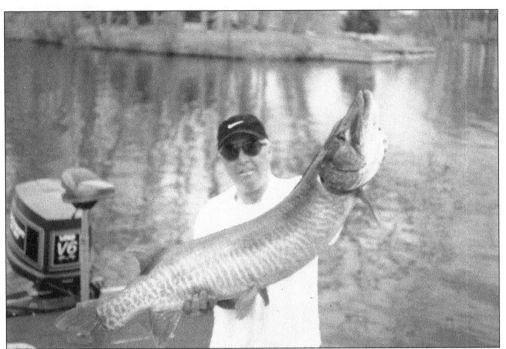

There are some large fish in Portage Lakes, and this one holds an Ohio state record. Ron Kotch caught this 31.5-pound, 47-inch-long, and 24-inch-girth tiger muskie in Turkeyfoot Lake in 1999. The fisherman that he is, Kotch also holds the state record for an eastern chain pickerel caught in Long Lake in 1961. (Courtesy of Ron Kotch.)

Portage Lakes State Park attracts 1.5 million recreational visitors to the area annually. Boating, fishing, swimming, hiking, camping, hunting, and a variety of winter sports activities are available on the reserve. One thousand acres of land and 2,520 acres of water are set aside for the public to enjoy. Facilities in the park include campsites, eight boat-launch ramps, and seven picnic areas.

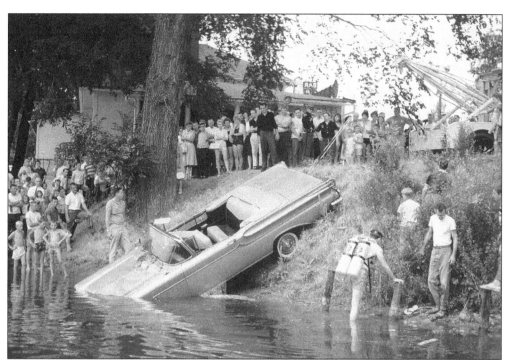

A curious crowd stands by as a Mercury convertible is pulled from the lake. Perhaps the vehicle was stolen, and the thief wanted to get rid of it; perhaps the owner missed a few payments to the bank, so the auto was driven into the water and reported stolen; or maybe the driver behind the wheel just lost control. (Courtesy of Division of Parks and Recreation.)

Steve A. Walker was born in 1949 in Bedford, Ohio. He spent 28 years at Portage Lakes State Park, serving as the park manager from 1984 until 2000. When Walker was park manager, his family's home was on the parkland in an old farmhouse. Steve's widow, Sandra, sons Stephen and Gregory, and daughter Jocelyn have fond memories of their time spent there. (Courtesy of Portage Lakes State Park.)

In the early 1940s, cottages located on the "Cat Swamp" at the north end of East Reservoir may not have been year-round homes. In the early part of the century, most houses were built to be used only during warmer months. Neighbors often shared hand-drilled wells, and every homestead had an outhouse. Eventually, homes were winterized, and residents stayed throughout the year. (Courtesy of *Akron Times Press*.)

Craftsman Park is a private park for Masonic families and their friends on Rex Lake. In the 1930s, the group had a campsite on Mud Lake. It purchased the Rex Lake Beach Park in 1945, and stories are told about floating cabins across the water to the present location. The new campsite included an old dance hall.

Four

RESORTS AND
SUMMER COTTAGES

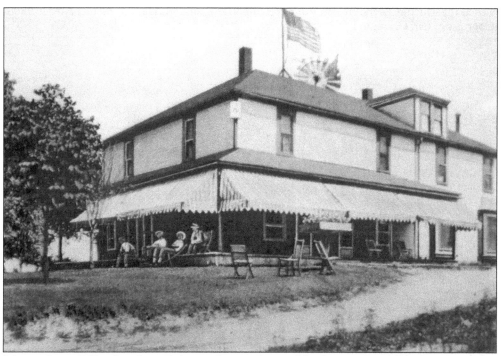

Johnny Groetz's Hotel on Long Lake was known for good food, a comfortable bed, and a spot or two of spirits. Built in the 1880s on Portage Lakes Drive near Saunders Avenue, it was later called Hotel Stebbins. Over the years, a variety of proprietors, including the Veterans of Foreign Wars, occupied the building. The Coventry Fire Department razed the decaying structure in 1970 to make room for additional parking for the Olde Harbor Inn Restaurant.

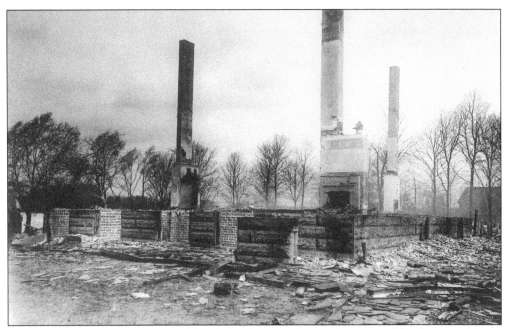

Lewis Young built a restaurant and hotel that became famous for some of the finest cuisine in the northern region of the Buckeye State. In 1907, a defective fireplace grate caused a blaze that burned the structure to the ground. Young rebuilt on the same foundation and reopened in 1908. (Courtesy of Earl Gessman.)

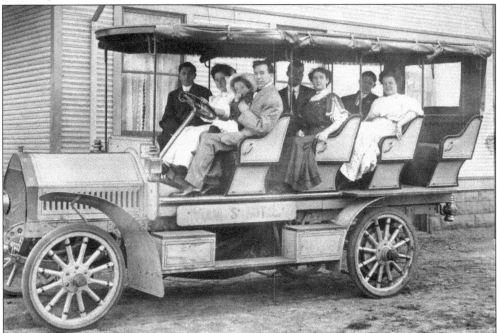

Lewis Young bought himself a jitney to transport guests to Young's Hotel and Restaurant on Manchester Road. Coal, oil, and gas-jet lamps were replaced with electrical fixtures. The old building was upgraded, and modern gas stoves replaced wood burners in the kitchen. Prominent guests at the lodging included Pres. William McKinley, Thomas Edison, and Harvey Firestone.

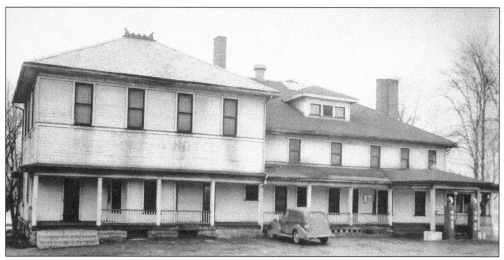

In the early part of the century, 10 grandchildren and their parents were involved in the family business and occupied Young's Hotel rooms; little space was left for customers. Lewis and Emma retired in 1948, and Claude and Stella May Young Brown took over the operation. The business remained in family hands for over 160 years. The final proprietors were Karen R. and Richard E. Brown. (Courtesy of *Akron Beacon Journal*.)

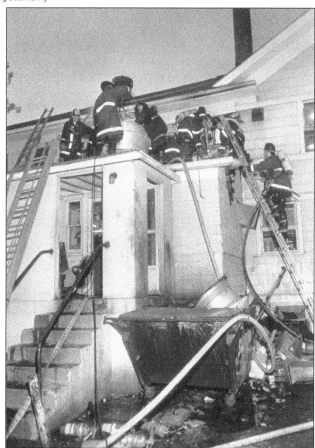

A kitchen fire caused considerable damage and an incredible amount of smoke at Young's Restaurant on Manchester Road in 1981. Local firefighters worked to keep the flames from moving to other parts of the ancient structure. As with many old buildings, the smallest flame quickly got out of control. (Courtesy of *Akron Beacon Journal*.)

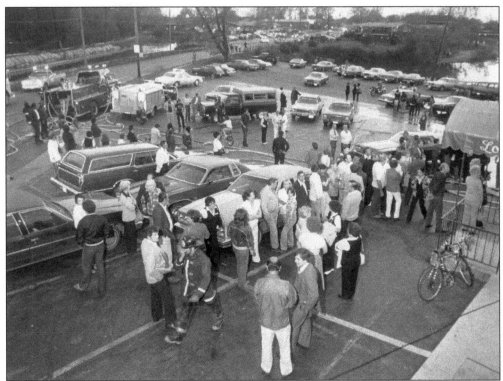

A crowd gathers in the parking lot of Young's Restaurant in 1981 in the aftermath of the kitchen fire. Always a popular spot on Manchester Road, the historic building suffered many blazes during its 160-year history. It originally started out as a cabin situated between Nesmith Lake and the feeder waters that came from Long Lake to support the Ohio Canal. (Courtesy of the *Akron Beacon Journal*.)

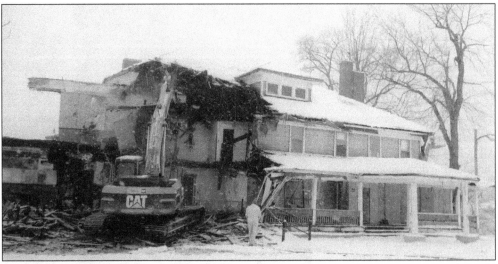

On December 6, 2010, after thousands of banquets, wedding receptions, parties, and family outings, Young's Restaurant felt the bite of a Caterpillar shovel. The antique building was in a state of disrepair, and the new owner chose to raze the structure to make room for a 21st-century building. (Courtesy of Ken Patterson.)

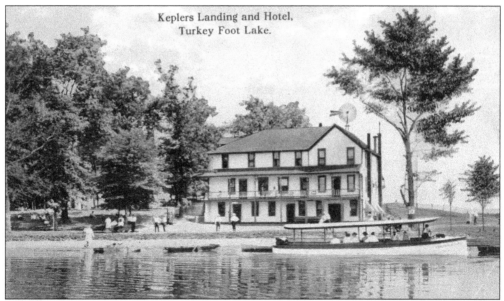

Keplers Landing and Hotel,
Turkey Foot Lake.

William Kepler erected a large three-story building on the south side of Turkeyfoot Lake in 1896. The occupants were mostly coal miners who were working the mines in the Manchester area. It was not long, however, before Kepler's Hotel and Landing began to attract guests who arrived by horse and carriage from the Massillon and Canton areas to spend time in the lovely country setting.

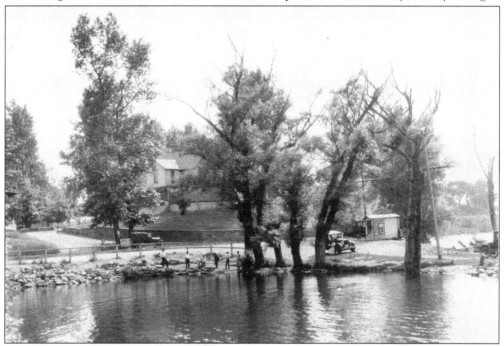

Albertson's Inn on West Reservoir, known as one of the best "resort eating houses" in Portage Lakes, was run by Anna and Ben Albertson from 1900 to 1941. In 1951, the empty complex was converted into apartments and managed by Cora Jennings until 1976. Numerous safety violations caused the Coventry Fire Department to raze the sagging building, allowing real estate developer Ken Payne to purchase the property for Mariner's Point Condominiums.

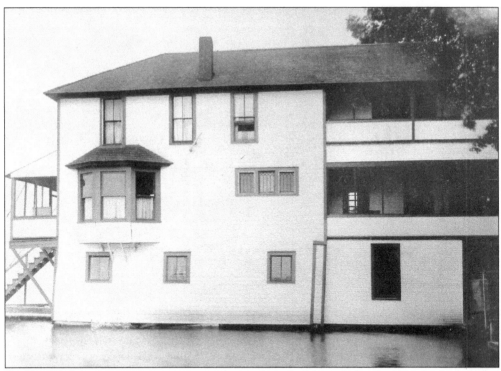

Freddie Work built a unique cottage on the south end of Long Lake. In 1908, he leased land from Frank Cormany and water rights from the State of Ohio. More than three-quarters of the structure was built over water. A popular trend of the time was to create new names by spelling names backwards. Work called his retreat the Krow's Nest. (Courtesy of Earl Gessman.)

Freddie Work was considered one of Portage Lakes' premier playboys. His father, Alanson Work Jr., was vice president of the B.F. Goodrich Company and died at the age of 39. Freddie's mother, Henrietta Lane Work, was elected to the board of directors at Goodrich. "As long as smoke comes from Goodrich, my Freddie will never have to work," she remarked to socialite friends. (Courtesy of Earl Gessman.)

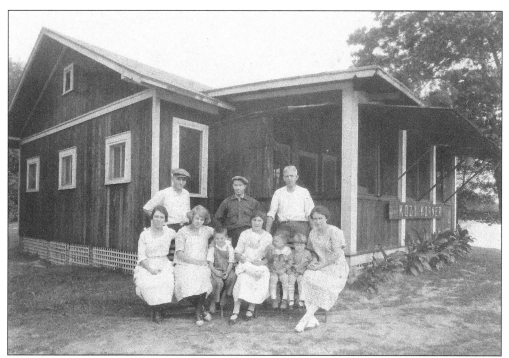

The cottage Kozy Korner was built in the early 1900s by Parke H. Thornton and friends on West Reservoir in the vicinity of the Turkeyfoot Golf Course. It was not far from the original farmhouse and former stagecoach stop now known as the Upper Deck. Like many of the cottages at the lakes, Kozy Korner was winterized and occupied year-round after World War II. (Courtesy of Mary Mozingo.)

The view of the inside of a typical cottage on Turkeyfoot Island in the early 1900s shows bare walls and a wood-burning fireplace. Frank S. Lahm, owner of the island, would not allow trees to be cut down. As a result, even the huge clubhouse has a tree growing through the roof. (Courtesy of Turkeyfoot Island Club.)

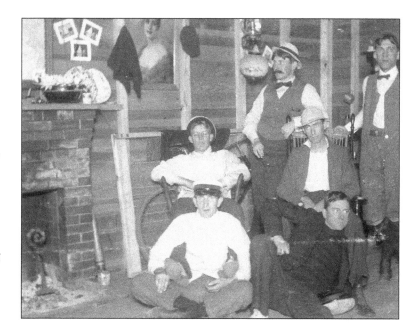

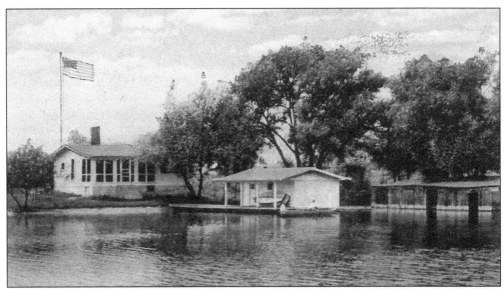

The B.B. Chapman cottage located on West Reservoir, pictured here in 1918, was typical of the rural open spaces in the lakes at that time. Building lots were reasonably priced, and it was common for folks from Akron, Canton, and Massillon to build summer homes. Families would move to the lakes for the warm months and then board up the dwellings and go back to the city in the fall.

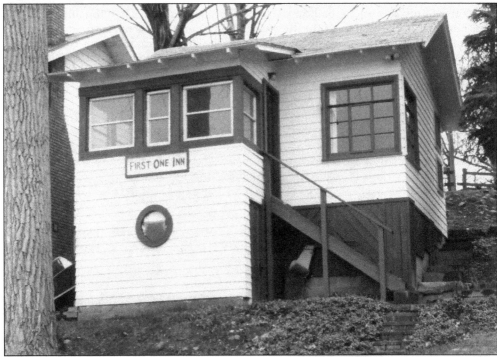

Even today, properties are narrow and houses close together in the lakes area. In the early 1900s, Portage Lakes was considered rural and appropriate for summer cottages. This cottage, the First One Inn, was updated and is shown here with modern windows and classic siding. Today, this structure on West Reservoir is gone, and in its place is a beautiful tri-level home. (Courtesy of Jim and Mary Miller.)

James and Bert Smith were married in 1892 and built their cottage on Hedgewood Drive, near the Turkeyfoot Golf Course, in 1905. Horse and buggy was the mode of transportation at that time; furthermore, James did not have a car or begin driving until 1908. The cottage had already undergone several renovations when this picture was taken. (Courtesy of Bev and Tom Fry.)

Motorized vehicles finally came to the Portage Lakes area. This young girl is going nowhere on the Harley Davidson motorcycle, but she is enjoying an imaginary ride. Early visitors and residents arrived by horse and buggy, canoes, or water launches. Roads were mere dirt paths and became muddy challenges during spring rains.

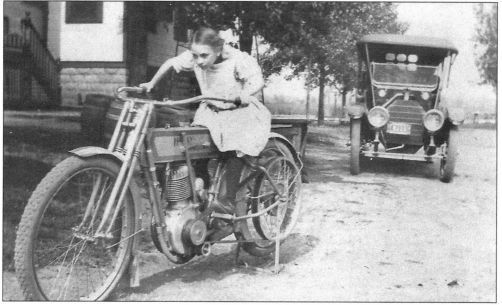

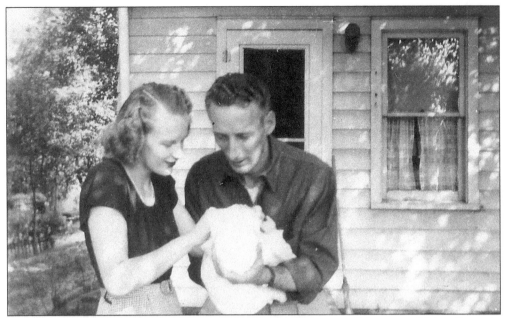

Dorothy and Durell Wayland tend to baby Pam outside their small home on Wrico Street in 1946. When World War II ended, and servicemen began returning home, there was a shortage of available housing for young families. Frank and Neva Eckroad built several small cottages that were quickly occupied by baby boomers and their families. (Courtesy of Pam Wayland.)

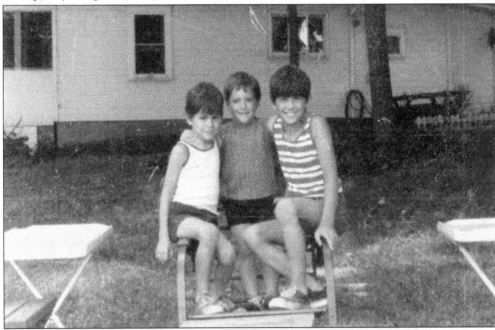

Sylvia Johnson, director of the Hower House in Akron, Ohio, and her husband, Howard, used the old cottage on Mud Lake for family summer getaways for several years. A new house was built in 2001 that incorporated materials that were salvaged from the old cottage. Enjoying fun at the lakes in the 1970s are, from left to right, Todd Johnson, cousin Andrew Neidert, and Jay Johnson. (Courtesy of Todd and Sylvia Johnson.)

Five

SUMMER PLAYGROUND

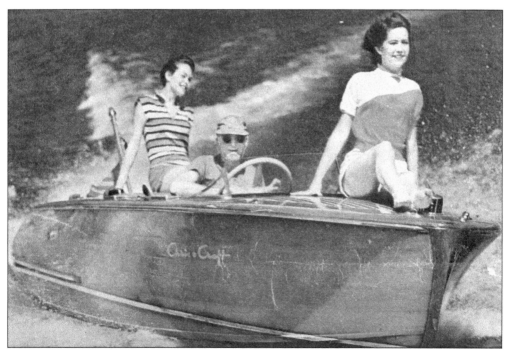

With more than 1,200 docks and nearly 500,000 boats cruising the waters annually, Portage Lakes is a favorite playground for young and old alike. Thurman Taylor, zoning inspector for Coventry Township, creates a considerable wake as he gives the beautiful Farris sisters a thrilling ride atop a wooden Chris Craft in 1954. (Courtesy of *Akron Beacon Journal Roto.*)

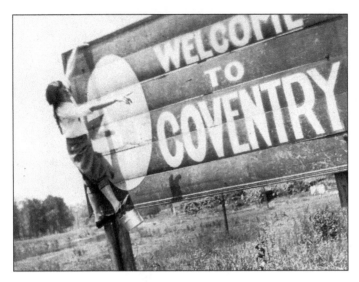

Ann Klein Cornell is balancing on the "Welcome to Coventry" sign in the 1920s. The Cornells did not have a cottage at the lakes, but Ann spent time with friends who did, Gertrude Miller Schill and Esther Bliss Miller. The sparse landscape portrays Coventry as yet undeveloped. Perhaps the berry bucket hanging from her foot was to harvest the huckleberries that grew profusely in the area. (Courtesy of R.C. Norris.)

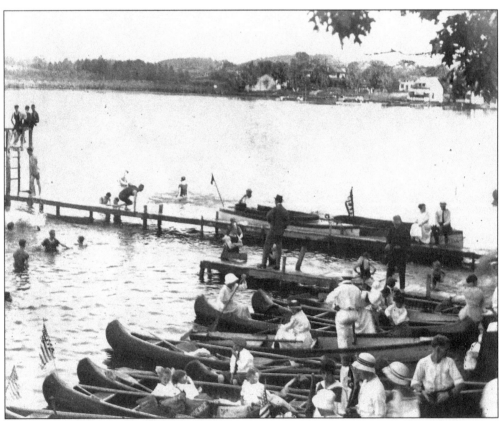

At the turn of the 20th century, there were canoe liveries from Akron through Portage Lakes, including Akron Canoe Livery (Zautner's), South End Boat Livery, Norka Canoe Livery (Thierry's), Akron Boat Livery (John Brunner's), Booth's Canoe Livery, the Tippecanoe Club, Halcyon Canoe Club, Cooper's Canoe Livery, the Anchor Canoe Club, and the Portage Path Canoe Club.

What could be more fun then a day at the lakes with special friends? From left to right, Dolly Smith, Bob Samples, Neatzie Samples, and Clyde Chatlin are perched on an antique car in the early 1950s. Ohio became one of the country's major amusement centers, with Euclid Beach, Luna Park, White City, Gordon Gardens, Puritas Springs, and Willoughbeach. Parks in the Akron area included Summit Beach, Silver Lake, Brady Lake, Springfield Lake, Chippewa Lake, Myers Lake, Randolph Park, Lakeside, and Sandy Beach. (Courtesy of Neatzie Samples.)

The Pequignot family came from a French settlement near Warren, Pennsylvania, to Portage Lakes shortly after World War I. In 1922, the Pequignots purchased property on West Reservoir and soon established themselves as savvy entrepreneurs. Pick's Boat House took advantage of the country's growing interest in canoeing and housed between 250 and 300 canoes. Folks came for the day, others for a week, and many stayed the entire summer.

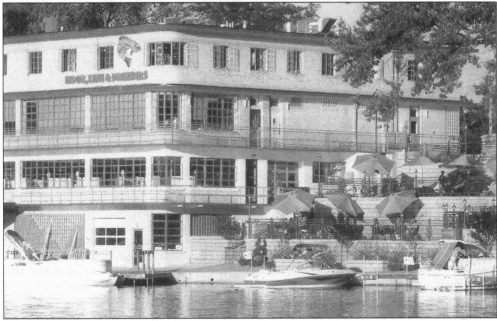

There was only a dirt road leading from Akron, but people liked the idea of coming to the country and did not mind the lengthy trip. The Pequignots ran a much-needed local grocery store, a custard stand, and a real estate business, and they soon expanded their two-story building. Today, Hook Line and Drinkers occupies a portion of the structure.

Neatzie Samples enjoys the ride while hubby Bob does the paddling. The young couple spent their honeymoon in the early 1950s in Canton, Ohio, before returning to the Portage Lakes area to canoe on beautiful Turkeyfoot Lake. (Courtesy of Neatzie Samples.)

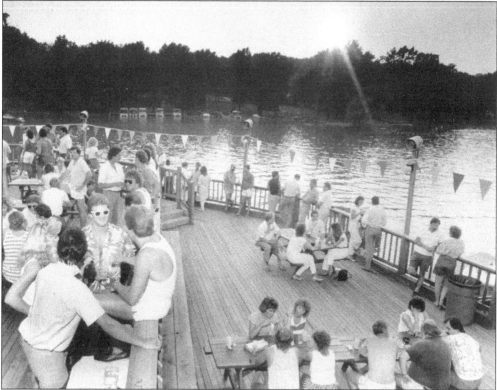

A summer crowd of young adults gathers on the deck of Pelican Cove on South Main Street, where the old Sandy Beach Amusement Park was originally located. Ownership changed several times; by the mid-1990s, the Chris Maggorie family of Canton owned the property and ran the restaurant and bar. Pelican Cove closed, and contemporary homes were built in Heron's Point in early 2000. (Courtesy of *Akron Beacon Journal*.)

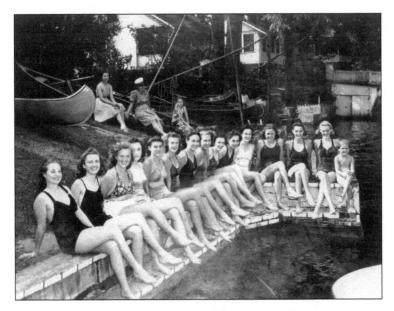

Fourteen bathing beauties and one young boy pose for the camera in the 1940s. Most of these young women grew up and lived near water into adulthood. Not only do they look pretty sitting on the sea wall, but they are precision swimmers who once performed for the National Soap Box Derby. (Courtesy of R.C. Norris.)

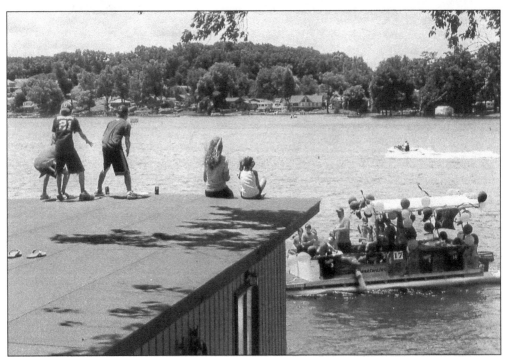

Youngsters atop a boathouse cheer on No. 17 in the annual Fourth of July boat parade. Community organizers sponsor activities surrounding the holiday throughout the year with fundraising activities. In addition to the boating events, 50,000 to 75,000 people line the banks and waterways to see privately sponsored fireworks.

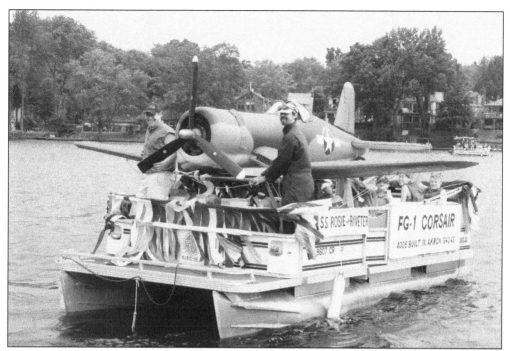

This Styrofoam FG-1 Corsair motors along in the annual Portage Lakes boat parade. The real Corsairs, popular carrier-based fighter-bombers, were built by Goodyear Tire and Rubber Company of Akron. The powerful airplane flew thousands upon thousands of missions during World War II. These would-be pilots named their ship the SS *Rosie the Riveter*. (Courtesy of the Frank Weaver Jr. collection.)

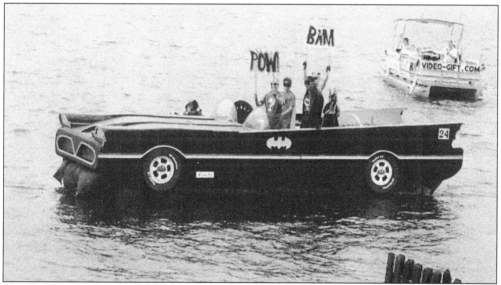

Since the mid-1970s, each Fourth of July celebration at the lakes includes fireworks, an antique boat show, and a boat parade. The Batmobile cruises along during the boat parade in 2006, claiming first prize among entrants. Creative participants often spend days building and decorating boats for the event. The three-hour parade attracts observers along the designated route from East Reservoir to Turkeyfoot Lake. (Courtesy of Alan Giles.)

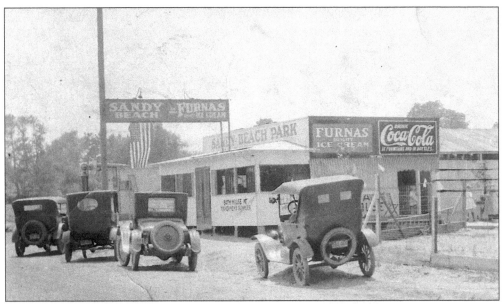

Sandy Beach Amusement Park was owned by "Swannee" Warensford and was operated many of its 44 years by his nephew Tom Longworth. The favorite swimming hole also featured a large dance hall with name bands, an outdoor boxing ring, summer cabins, midway games, mechanical rides, and water sports. The park was dismantled in 1965. (Courtesy of Tom Longworth.)

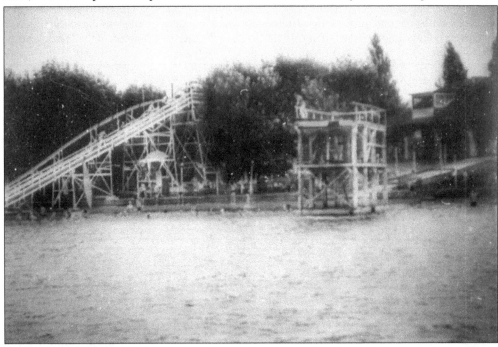

In the early 1920s, the Alexander H. Commins estate on South Main Street included Sandy Beach Park and an undeveloped acreage later known as Turkeyfoot Heights. The new owner made significant modifications, including a high diving board and toboggan waterslide. There was a full boathouse with rental canoes and a launch ride that circled the lakes. (Courtesy of Tom Longworth.)

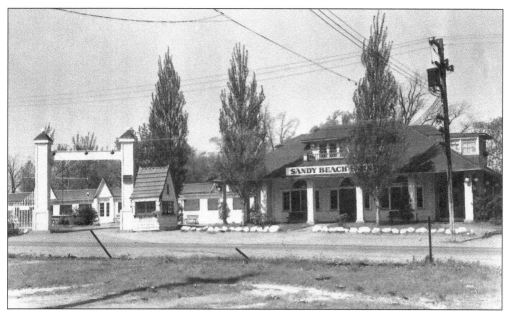

Believe it or not, amusement parks appeared on the East Coast as early as the 1700s. Playgrounds for the young and wealthy featured name bands, fine hotels, and sexually segregated beaches. By the late 1800s, parks were attracting the blue-collar worker and his family. Large companies, churches, and union groups held annual picnics at Sandy Beach. (Courtesy of Tom Longworth.)

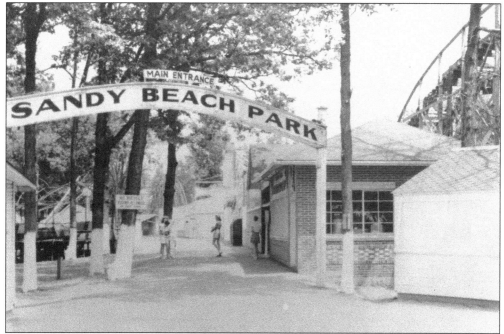

Hundreds of kids took Red Cross swimming lessons at Sandy Beach, and the Firestone Swim Team used the popular spot for practices. Fire destroyed many of the buildings in 1961, and Warensford eventually sold the land to Paul Tell of the Akron Coffee and Grocery Company. Ownership changed hands several times, and ultimately the property on South Main Street became the upscale Heron's Point. (Courtesy of Tom Longworth.)

Swannee Warensford, proprietor of Sandy Beach Amusement Park, operated a small restaurant, built cabins, and enclosed the original picnic pavilion, making it into a dance hall. He invited the country's top orchestras to play for overflowing crowds. In addition, on weekends an outdoor boxing ring featured rough-and-ready young men defending their titles in front of packed audiences. (Courtesy of *Akron Beacon Journal*.)

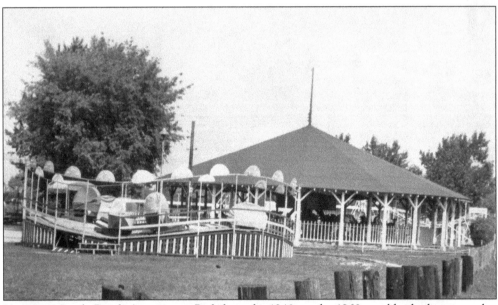

Visitors to Sandy Beach Amusement Park from the 1940s to the 1960s could ride the carousel, a small roller coaster, a Ferris wheel, child-sized boats, a Tilt-a-Whirl, and a miniature locomotive, whose tracks wound throughout the five-acre common. For a bit of pocket change, patrons could try their luck at the duck pond, basketball, shooting gallery, penny pitch, and the penny arcade attractions. (Courtesy of the *Akron Beacon Journal*.)

With sailboats in the background, an unidentified girl enjoys soaking up the sun on Pin Oak Point Beach in 1947. A plat map dated 1935 shows 103 lots in the Mason Turkeyfoot Lake Allotment No. 1, selling from $375 to $2,000. Homeowners incorporated in 1947 and decided on Pin Oak Point as a name because of the huge oak trees. (Courtesy of Eleanor Stroup.)

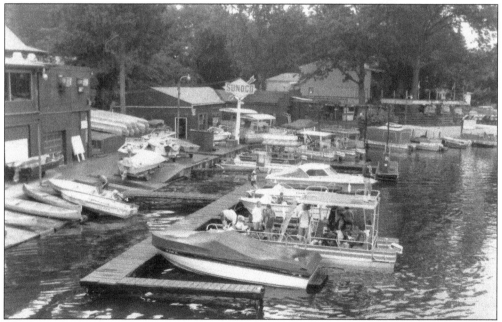

The boats docked here at Dietz's Landing & Restaurant on Turkeyfoot Channel in the 1970s are ready for a great day on the water. Notice the rental canoes stacked in the upper left as well as directly in front of the building. Visitors to the lakes have been renting canoes since the early 1900s. In recent years, pontoon-boat rental is another option.

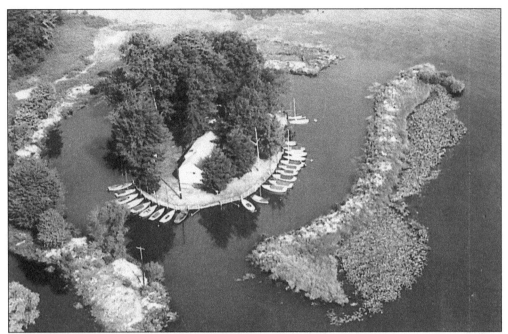

South Shore Yacht Club was launched by a group of sailors beneath a large tree at Kepler's Landing on the south shore of Turkeyfoot Lake during the summer of 1937. Dredging on the lake in the mid-1950s left the club on an island. The late Mary Kepler Shrake granted the club perpetual easement for island access. Dues were $1 and included a membership card, a club flag, and all club privileges. (Courtesy of Lew Roberts.)

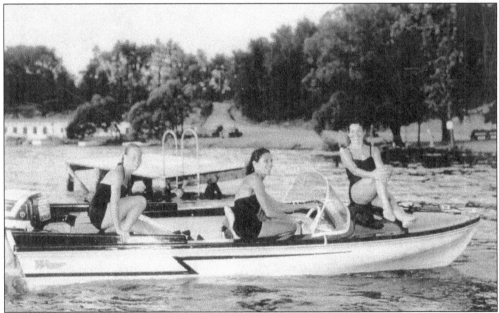

These girls out for an afternoon of water-skiing are taking a rest on Swiegarts Bay at the south end of Mud Lake. A ski jump and calm waters provide an ideal place for the Akron Ski Club to practice. Leighton's Boat House can be seen in the background. The bathing beauties, from left to right, are Sue Brewster, Lucille Borgen, and Martha Fritz. (Courtesy of R.C. Norris.)

Ohio's most popular inland body of water for recreational water sports is located approximately 30 miles south of Lake Erie in Summit County. Portage Lakes State Park attracts about 1.5 million visitors annually. Water-skiing is now restricted to two main areas in the chain of lakes. At designated times, skiing is permitted on Turkeyfoot Lake and East Reservoir. (Courtesy of Bill Hunter.)

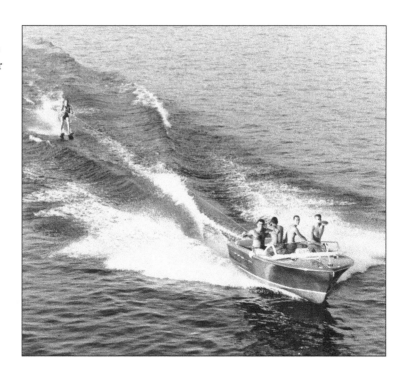

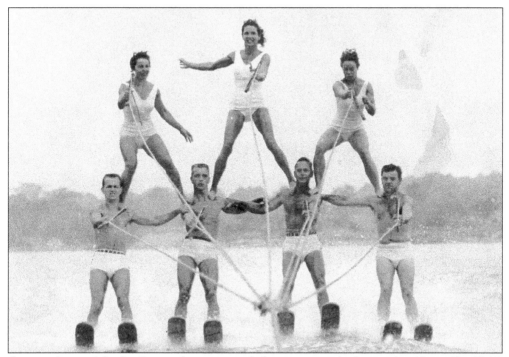

Coventry's own Martha Fritz and teammates balance cautiously during the Akron Ski Club's impressive performance. Many of the talented water-skiers were recognized throughout the nation. Pictured from left to right are (girls) Martha Fritz, Lucille Borgen, and Sue Brewster; (guys) Tom Hilbert, John Koegler, Harold Miller, and Aubrey Hupp. (Courtesy of R.C. Norris.)

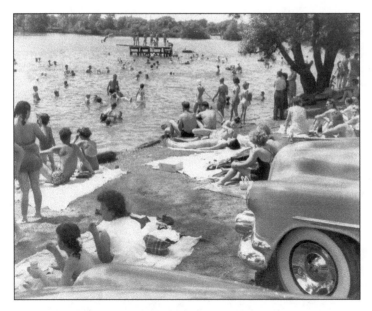

Originally called Swannee's Place, the popular Longworth's swimming hole was located on the north side of North Reservoir. Swannee Warensford opened the Portage Lakes Drive business in the 1930s and eventually sold it to his brother-in-law John "Pokey" Longworth. Longworth, his wife Myrtle, and sons Robert and Thomas operated a grocery store, swimming hole, and picnic area until 1957. (Courtesy of R.C. Norris.)

In 1925, Parke Thornton and siblings opened the first public golf course in Summit County. Turkeyfoot Golf Course celebrated its 75th anniversary in 2000. Pictured here are some of the 20 directors and officers of the privately owned course. They are, from left to right, (first row) Lois McCorkle, Marilyn Stern, Mary Mozingo, and John Thornton; (second row) Martha McCorkle, Fran Medhurst, JoAnn Minno, and Mark Alexich. (Courtesy of Mary Mozingo.)

Martha Fritz was an outstanding water-skier well known in Portage Lakes for continuing to ski when others would have been sitting in their rocking chairs. She was recognized by the American Water Ski Association Hall of Fame in Winter Haven, Florida, and spent a lot of time in Cypress Gardens, Florida. Fritz taught dance for many years and remained active until her death at the age of 86 in 2009.

Bill Allen (left), the unofficial mayor of Portage Lakes, R.C. Norris (center), proprietor of Dusty's Landing, and the late Glenn "Jeep" Davis, a world-record holder and Olympic gold medalist in track and field, are seen sharing friendship and great stories about the lakes, a community like none other for miles around. "Lakers," as locals call themselves, believe there is no better place to live.

The Goodyear Boating and Yachting Association was founded in 1955 when Goodyear employees presented the idea of a boat club to the Goodyear Tire and Rubber Company Activities Department. A temporary home port was located at Oak Ridge on Cottage Grove Lake. In this picture, the old 4,000-square-foot dance hall picnic pavilion can be seen in the background. (Courtesy of Goodyear Boating and Yachting Association.)

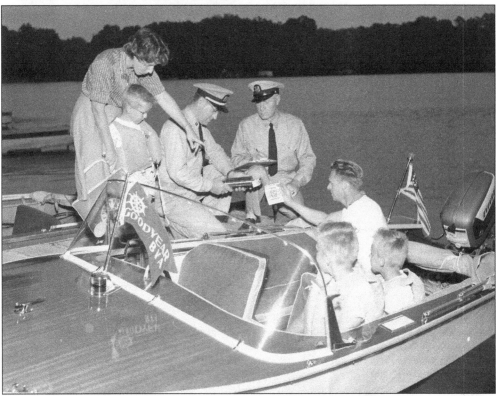

Coast Guard Auxiliary officers Warren Adkins (left) and Clarence Wilson conduct boat a inspection in 1958. The young Goodyear Boating and Yachting Association family watches closely as officers review requirements and certify compliance. Following World War II, there was a dramatic increase in the number of recreational boat owners, and the Ohio General Assembly created the Waterway Safety Fund. (Courtesy of Goodyear Boating and Yachting Association.)

Six

EAT, DRINK, AND BE MERRY

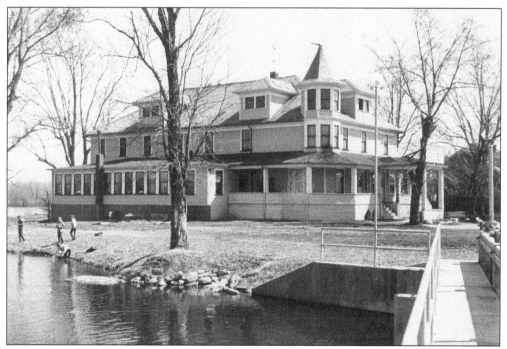

The popular Smith's Tavern on the east side of Manchester Road near the Long Lake Channel was built by George M. "Duke" Smith in 1906. The large building served as a hotel as well as a tavern, and Duke provided transportation to his place by picking up customers at Cooper's Boat House at South and Bowery Streets in Akron. Taking advantage of the locks, Summit Lake, and the Ohio Canal, he delivered his precious cargo to the tavern. Other customers were picked up by horse and buggy from Manchester Road and Kenmore Boulevard. (Courtesy of Harry Welch.)

George Smith's parents immigrated to the United States from Germany in 1853 and found themselves a long way from their homeland. Son George eked out a living in a variety of ways, one of which was as a bartender. Learning from watching the successful operation of Young's Hotel, Smith struck out on his own. (Courtesy of Harry Welch.)

Smith's Tavern became Welch's Tavern in 1934 as a result of the marriage of George Smith's lovely daughter Margaret to Howard Welch. Howard was the son of Akron's chief of detectives, Harry A. Welch, an Irish immigrant noted for his exceptional police work in the capture and conviction of the notorious Borgio Gang, killers of three Akron policemen in 1929.

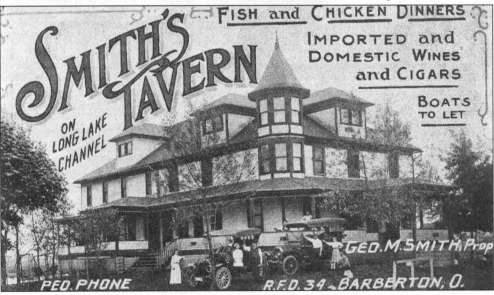

Howe and Margaret Smith Welch (pictured) ran Welch's Tavern during the 1930s and sold the business to Paul Kraychek and Bill Brown in the late 1940s. Kay Breitenstine operated the establishment for a short time. Eventually, Vincent Vatalaro, owner of the Owl Cigar Store, bought the tavern. Unfortunately, Vatalaro was shot to death at Nick Yanko's Restaurant in Akron before the tavern could be reopened. (Courtesy of Harry Welch.)

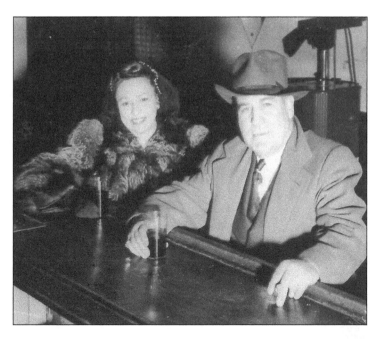

In 1969, Welch's Tavern on Manchester Road was in a state of disrepair and was torn down. The property was sold to Red Barn Restaurants, which eventually filed nationwide bankruptcy. Harry J. Welch, son of Howe and Margaret Welch, purchased the property in 1990. Later, Velvet Car Wash owned the property, and by 2002 Ron Sykes of R.J.S. Construction Company held the deed. (Courtesy of Harry Welch.)

Frank Crooks rented out the hotel building on Portage Lakes Drive, and it soon earned a reputation as a gaming establishment. Between 1919 through 1954, the notorious gambling house on the south shore of Long Lake was called Hamlin's, Lies, Duffy's Tavern, Mitzi's, Riley's, and finally Lindy's. Arson was suspected when the old structure was gutted in an early morning fire in 1954. (Courtesy of Rose Ann Crooks Clark.)

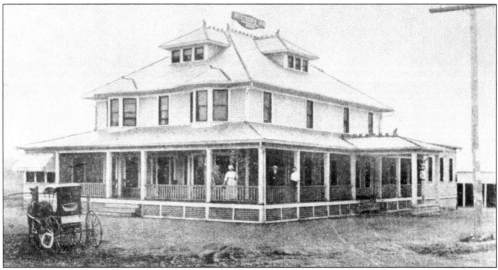

It was originally called Connor's Inn, but by the 1930s Mickey Bertsch was running the tavern on the southwest corner of Main Street and Waterloo Road. The establishment was frequently raided by law enforcement. Sales of illegal liquor often meant that the proprietor would go to jail. Bertsch's place served as a lookout for other saloons. Word traveled fast, and any illegal hooch was quickly hidden.

In the 1940s, as many as 26 tavern owners were relieved when Coventry passed the wet vote 2,302 to 1,002. Portage Lakes, however, developed a reputation as a rowdy location. Youths roamed the streets and became a nuisance. In the 1950s, these tavern owners eventually assisted the township in building the PLAY (Portage Lakes Active Youth) center on Willowview Drive. Volunteer managers were called "Play Pops" and Play Moms."

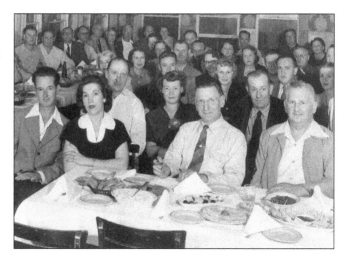

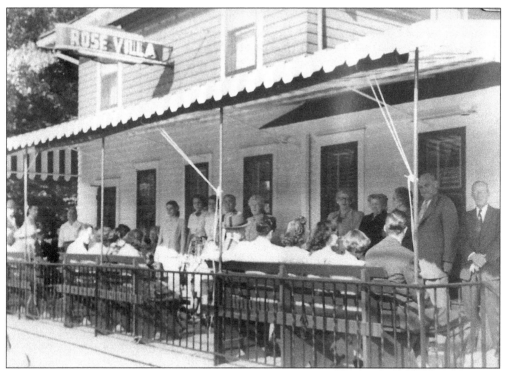

It was in 1928 that Ralph and Clara Durst lived upstairs and opened Rose Villa Restaurant on the lower level of the house on Portage Lakes Drive. Business was brisk, and customers waited on the porch to be seated. Snow collapsed the porch roof in the 1970s, shortly before Dominic and Anna Fana and their son Dominic purchased the restaurant.

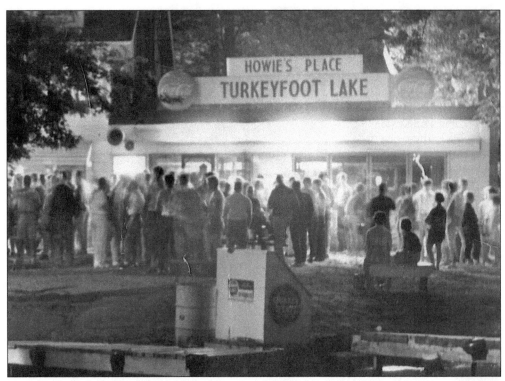

Howie's on the Lake has been a favorite hangout for decades. It was formerly known as Caston's Landing, and stories are told of slot machines and other attractions often overlooked by the law. Howie and Ada Geis purchased the business in the 1950s. Other owners included Bob Joecken, Jim Nay, Karl Chalmers, and Willie Dietrich. Finally, in 1973, Max Guscoff became the proprietor of the popular watering hole on Turkeyfoot Lake.

Felix Krasinski came to Ohio from Poland in the 1930s and developed the Falcon Chateau as a dance hall. Behind the property on East Caston Road, he built a small brick house that was known to family and friends as "the farm." Krasinski worked at Goodyear and spoke several languages. He had two sons and several daughters. The Falcon Lounge has changed owners many times since its dance-hall days.

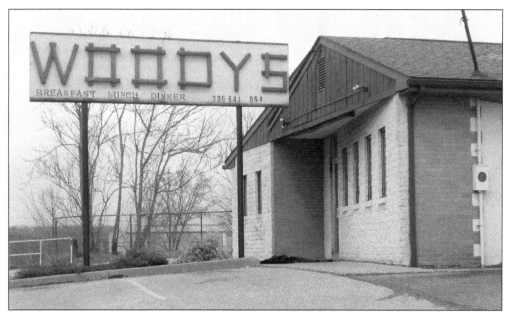

Jim and Joyce Woodling purchased P.J. Gridiron on South Main Street in 1985 and turned it into one of the most popular eating spots in the Portage Lakes area. Immediately after acquiring the business, they enlarged the building, increasing the seating capacity from 44 to 84. Jim passed away in 2005, and his children Theresa Dunn, Erin Craiglow, and Kyle Woodling operate the little restaurant that is well known for its great breakfasts and comfort foods.

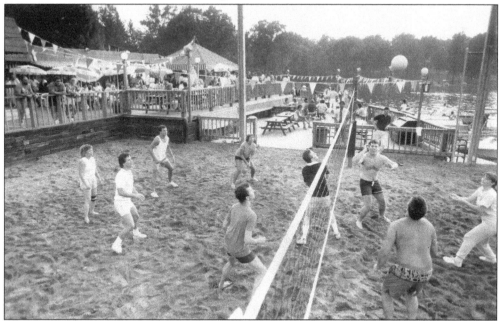

An active game of volleyball takes place in the sandpit at Pelican Cove on East Reservoir. The area, on South Main Street, had an extensive entertainment history dating to the 1920s. Through the years, an amusement park, restaurant, tavern, dance hall, and picnic grounds occupied the acreage. Today, an upscale housing development has replaced the aging buildings. (Courtesy of *Akron Beacon Journal*.)

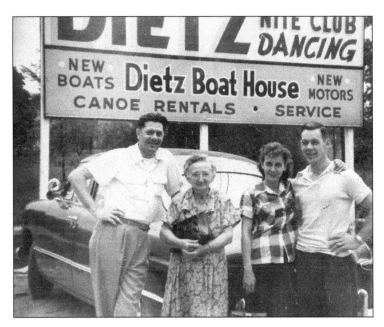

In 1947, Dietz Boat House on West Turkeyfoot Lake Road sold boats, rented out canoes, employed a boat mechanic, and was one of the favorite nightclubs in the area featuring live music. Petite Lou Ashley, clutching her large handbag, is surrounded by friends in front of the sign advertising the popular establishment. (Courtesy of Bob Ashley.)

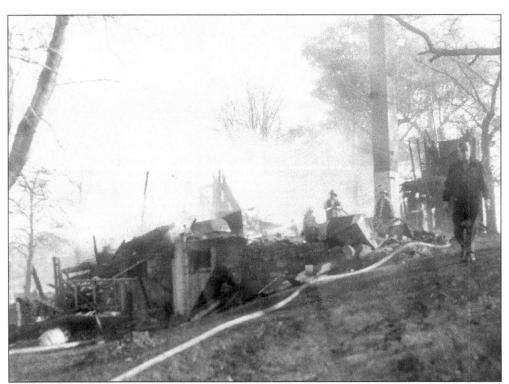

The first floor of this establishment was called the Riviera Supper Club and the second floor the New Yorker. All was going quite well for Louis and Frank Ferraro on the south shore of Turkeyfoot Lake. Unfortunately, like numerous old wooden structures, the building burned to the ground in the fall of 1964. (Courtesy of Al Bollas.)

The Olde Harbor Inn draws a huge boating crowd on hot summer days. Located on West Reservoir, it was known as Mellinger's Hotel during horse-and-buggy days. In 1977, Glen Barensfeld bought the restaurant, previously known as Mangold's, Lighthouse Harbor Inn, Tony Schnur's, Old Harbor Inn, and Pete Shaffer's. Steve Burroughs and Richard Nicoletti acquired the establishment in 2007. (Courtesy of *Akron Beacon Journal*.)

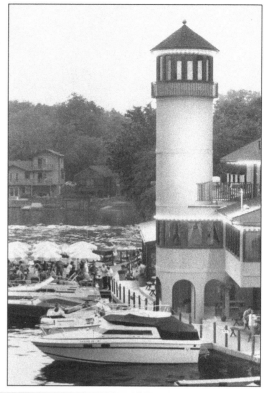

Pictured from left to right, Phil Ridgeway (lead singer and saxophone player), Bob Guest (guitar), Wally Renner (drums), and Mike Sampsel (piano) make up Phil 'n the Blanks, which has been entertaining northeastern Ohio for 11 years. Phil began his professional music career in 1974 with the Flashbacks. This group plays tunes from the 1950s through the 1980s, featuring doo-wop, Motown, and good old rock 'n roll.

The now vacant building at Portage Lakes Drive and South Turkeyfoot Road was called the Lakes Blue Swan in the 1950s. Curbside and dockside service delivered hamburgers to the teenage crowd. By the early 1970s, teens lost interest, and the motorcycle crowd, ex-servicemen, and divorcees found companionship at the Lakes Blue Swan. Over the years, it has been known as the Outrigger, Froggies, Bumpers, and the White Rhino.

The Sunset Inn served delicious fried-fish dinners, and some would say that is was a front for bootlegging during the Prohibition era. Customers were admitted to the speakeasy through a locked entry, and owner Hayes frequently had the revenuers chasing him. Charlie and Pauly Anthe purchased the business in 1969 and ran the restaurant for several years. In the 2000s, new owners changed the name to Prime at Anthe's.

Seven

MAKING A BUCK

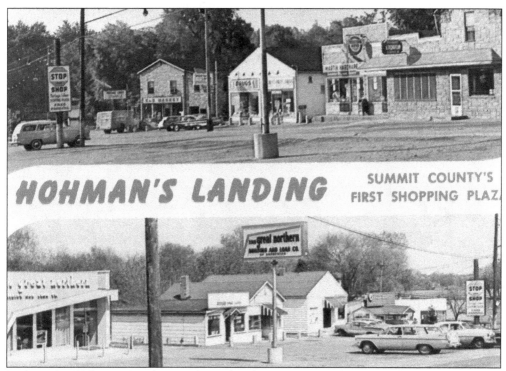

In the 1950s, Hohman's Landing was located at the intersection of Portage Lakes Drive and South Turkeyfoot Road. Pictured from left to right are (above) Deem's Grocery, Portage Lakes Pharmacy, Eberwine's Five and Dime, Martin's Hardware, and the Midnight Lunch; (below, across the street) the Great Northern Bank, a shoe-repair shop, doctors' offices, a beauty shop, and Junker's Gas Station. (Courtesy of Rose Ann Clark.)

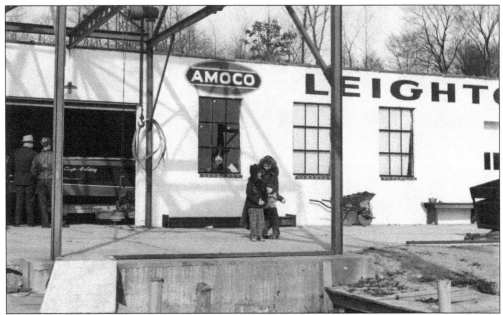

Leonard Leighton opened a boathouse on Mud Lake in 1946. Eventually, he purchased the defunct Warner Boat House on Portage Lakes Drive. His son Tom and daughter-in-law Joyce took over the businesses when Leonard died in 1985. In 1983, Ross and Laurie Kieffer purchased the nearby Burch's Landing. When the Leightons decided to sell the family business on Portage Lakes Drive, the Kieffers became the new owners. (Courtesy of Kieffer Marine.)

There were several small businesses in the Portage Lakes area that relied on local customers for survival. Many of the proprietors lived within the community and supported one another on a daily basis. The Midnight Lunch was a popular spot for a quick sandwich and a tasty brew. This picture was taken after the demise of the pharmacy, hardware, and the variety store. (Courtesy of Rose Ann Clark.)

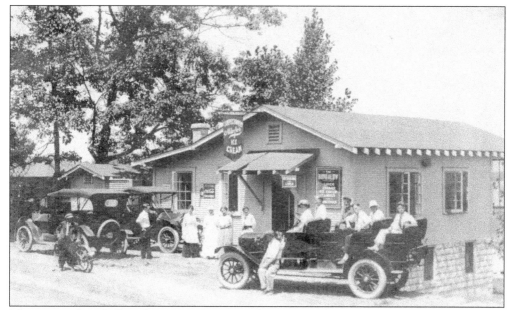

This postcard reads "Lunch room on Portage Lakes Drive on bend near Longworth's." Known as the Bungalow Lunch Room at 807 Portage Lakes Drive next to Crooks Hotel, its customers in classy autos pose on a hot summer afternoon. (Courtesy of Rose Ann Crooks Clark.)

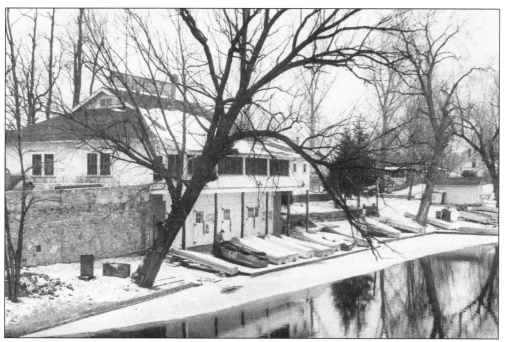

C. Gottlieb, also known as "Scroggy" or "Strogie," Dietz opened a grocery store on West Reservoir in 1923. He was able to obtain the first liquor license in the area after the repeal of Prohibition in 1933. For many years, he operated Dietz's Landing & Restaurant, a boathouse, and the Valderian dance hall. William Strawn and J.R. MacGregor purchased the business in 1944. Dietz's Landing is now owned by Mark Norris.

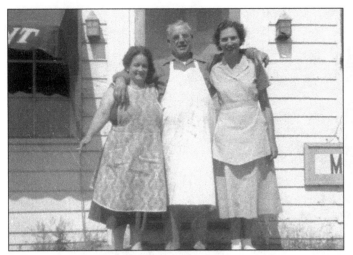

The Blue Roof Steak Station and Restaurant was located at Tarlton Avenue and East Turkeyfoot Lake Road, across the street from Kruger Plaza, in the 1950s. Owned by Clyde and Sylvia Vendosel, it was a favorite eating spot for those looking for down-home cooking. Clyde stands with an unidentified waitress on the left and Betty Anderson on the right. (Courtesy of Winston Anderson.)

Neighborhood grocery stores were the place where local housewives gathered to share the events of the day in the 1940s and 1950s. It was often possible to run a tab and settle up with the grocer when payday came around. Bronson's Grocery Store, located on South Turkeyfoot Road and formerly known as Bronson's, was that sort of place. Today, the building has been refurbished and serves as a residence. (Courtesy of Rose Ann Clark.)

86

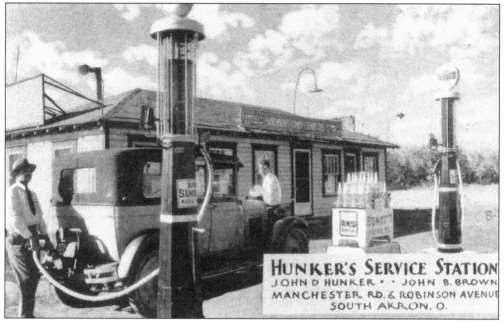

John Brown pumps Blue Sunoco gasoline into the automobile at Hunker's Service Station in the early 1930s. The station at the intersection of Manchester Road and Robinson Avenue carried ice cream, sandwiches, candy, cigarettes, and of course motor oil for the horseless carriage.

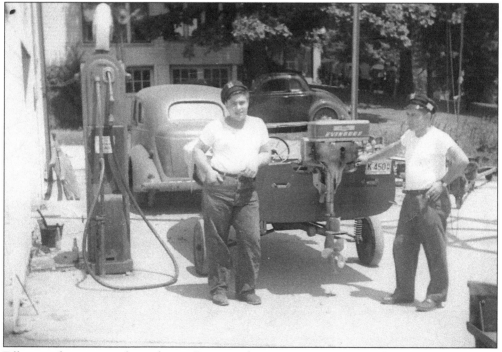

Filling up the motor with gasoline at Dietz's in the 1940s are Sonny Atler (left) and his dad, Ken. Most everyone living in the area had a boat of some kind. Carl Ashley managed the marine business from 1947 to 1951, when a couple of outboards and over 100 canoes were available for rental. (Courtesy of Bob Ashley.)

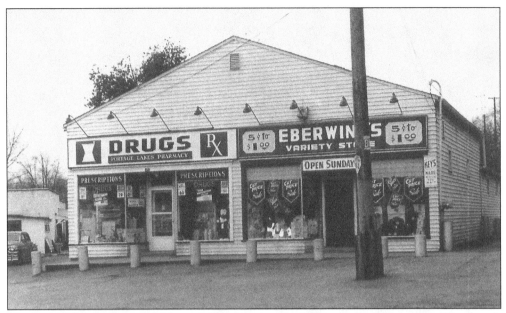

Eberwine's Variety Store at Hohman's Landing in the 1950s was the dollar store of its day. A spool of thread, a measuring cup, birthday candles, and hundreds of other items were stocked for the local shopper. The business was located on Portage Lakes Drive next to Don Maxwell's Portage Lakes Pharmacy. The pharmacy had a drive-up window, which was unheard of in that day. (Courtesy of Rose Ann Clark.)

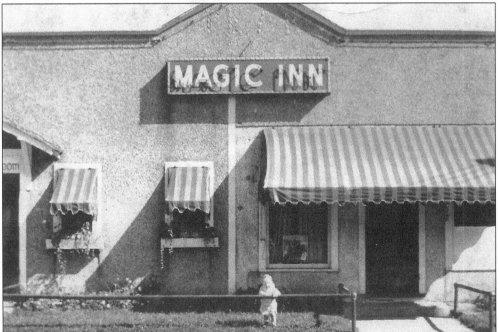

Few locals remember the Magic Inn on the east side of Manchester Road near the Long Lake Channel. In the mid-1940s, it went up in flames like so many other wood structure buildings before adequate fire department protection was available. Owners Ralph and Emma Shaw packed up their small family and moved to Florida without attempting to rebuild.

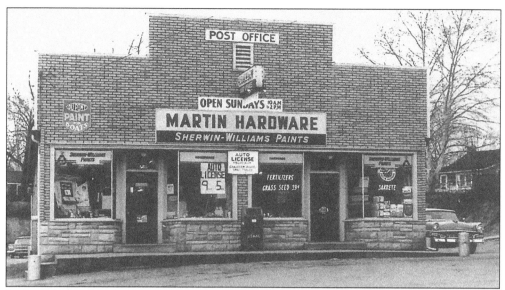

In the 1950s, Martin Hardware was on the northwest side of Portage Lakes Drive in an area referred to as Hohman's Landing. The hardware also served as the post office and license bureau. There was a variety of shops at Holman's Landing, and local residents rarely had to leave the lakes to meet daily needs. (Courtesy of Rose Ann Clark.)

Located on Manchester Road since at least the mid-1940s according to the Akron City Street Directory, the G. and J. Motel was owned by W.R. Jerrel, a grocer and Manchester, Ohio, resident. Jerrel is listed as the proprietor from 1943 to 1974. After that, Thomas and Martha Kreighbaum ran the establishment for a short time. By 1988, records indicate that Leonard F. Papp was the owner. (Photograph by Don Aldridge.)

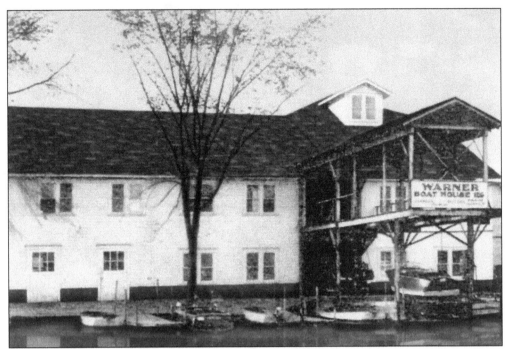

Rolland Warner was only 14 years old when he began working on boats in his dad's barn on East Reservoir. Abe taught his son the business, and Warner Boat House was one of the largest in the area. Repairs, fuel, motors, storage, and general boat maintenance kept the crew busy.

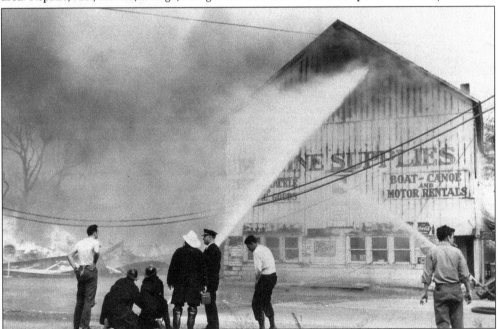

Warner Boat House on Portage Lakes Drive burst into flames in 1952. A kerosene torch placed too close to a can of turpentine caused an explosion that rocked the community. The entire three-story building burned to the ground, taking with it 250 boats, 500 to 600 motors, a house, and two Coventry Fire Department vehicles. (Courtesy of *Akron Beacon Journal*.)

Although water seemed to be accessible, pumping it from the lake in quantities capable of squelching the fire was impossible. The out-of-control blaze was fueled by the gasoline in boats in storage. The loss was estimated at $375,000, and there was little, if any, insurance covering the boats and building. Coventry suffered extreme financial loss when the fire consumed a fire engine and an emergency vehicle. (Courtesy of *Akron Beacon Journal*.)

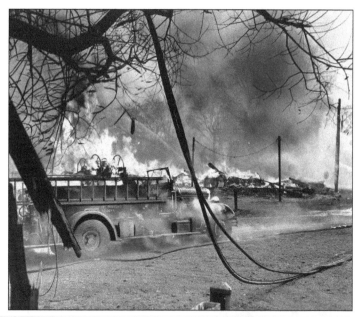

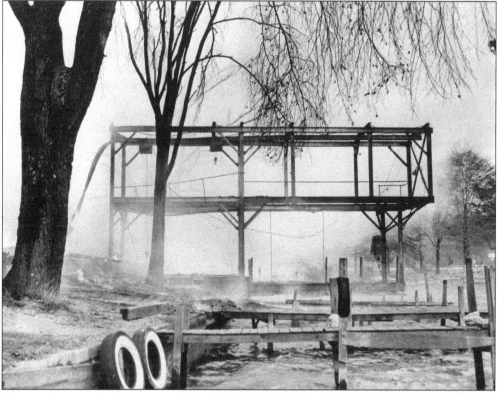

The wooden structure is gone, and angle-iron framework can be seen through the smoldering timbers at Warner Boat House in 1952. Financially, the devastating fire resulted in sale of the property. Leonard Leighton bought the defunct marina as well as a large parcel of land on the north side of the road. Ross and Laurie Kieffer of Kieffer Marine now own the marina. (Courtesy of *Akron Beacon Journal*.)

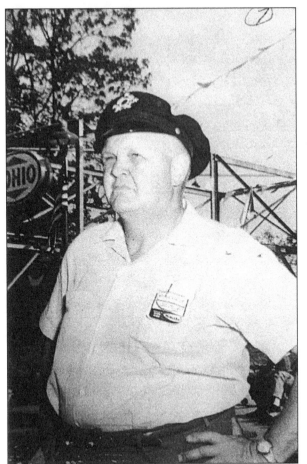

Often referred to as "Mr. Portage Lakes," Ned Mohrman was a popular individual among area residents. He operated the Sandy Beach Marina on South Main Street for 20 years. In 1938, along with other boat enthusiasts, he organized the Summit Motor Boat Association, later called the Akron Yacht Club. The group promoted boat racing and attracted some of the best drivers in the nation from 1947 through 1954.

Swannee Warensford, owner of Sandy Beach Amusement Park, built Sandy Beach Marina on the east side of South Main Street and leased the property to Ned Mohrman in 1957. Several other owners have been involved in operating the large marina since its inception. Situated on the south side of Cottage Grove Lake, it is currently owned by James and Zana Genovese. (Courtesy of Bill Hunter.)

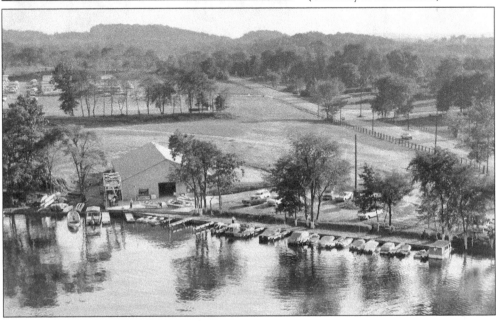

Eight

WATERCRAFT

In the late 1950s, Harry Walkner built this unusual looking boat that surprised avid motorboat enthusiasts in northeastern Ohio. The young boys taking a ride in the boat-airplane hybrid are James (left) and Lynn Barnett. For those who are curious, the contraption never left the water; even though it looks as if it could fly, it could not. (Courtesy of Laurie Norris.)

Most everyone residing on Turkeyfoot Island in 1905 had a boat or two. This family had plenty of room in the expansive launch moored at their dock when they decided to go for an outing. The privileged few who were able to build cottages on the island found boating, swimming, and sailing a respite from city life. (Courtesy of David Fielder.)

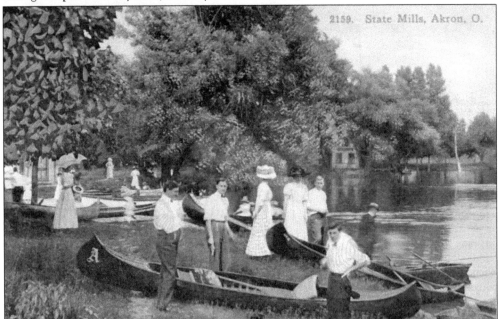

In the late 1800s and early 1900s, canoeing was a favorite activity, with fierce competition between clubs. It was possible to board a canoe in Akron and paddle or portage all the way to Turkeyfoot Lake in Franklin Township. Seen here is Albertson's Inn at State Mills, always a favorite place to grab a quick bite to eat and rest before the next leg of the trip.

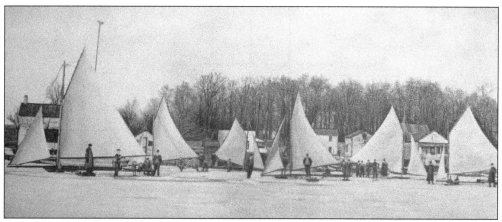

Ice sailboats gather on Turkeyfoot Lake in the early 1900s for a sailing regatta. Each craft is fitted with runners and will glide across the ice propelled by the wind. Several weeks of below-freezing temperatures are necessary in order for the ice on the lake to be strong and thick enough to support this activity.

Ray Baughman, second from right (behind the steering wheel), takes neighbors and friends for a ride on his homemade iceboat in the early 1900s. The area is still very rural in this image, although Portage Lakes Drive can be seen in the background. Jim Cormany's house is on the right, and Lloyd Hoch's home is second from the right. (Courtesy of Jean Baughman Provence.)

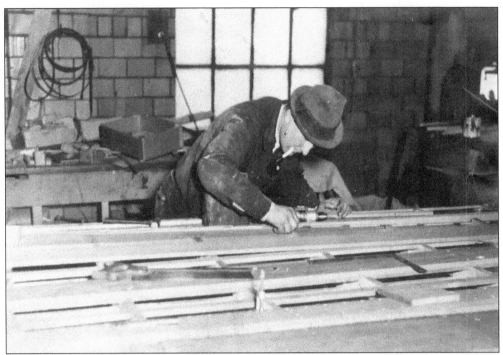

Charles F. Yakubik was a builder of premier watercraft in the 1940s. In the picture above, he is working on a special project in his shop on Brown Street in Akron. ABBCO (Akron Boat and Body Company) was known nationwide. Yakubik specialized in building everything from custom duck boats to twin-engine, gold cup–racing hydroplanes for the elite customer. Pictured below, nearly ready to drop into the water, is the hydroplane *Tomyann F-90*. Yakubik saw his designs raced from Ontario, Canada, to Florida. (Courtesy of Mary Yakubik Antenora.)

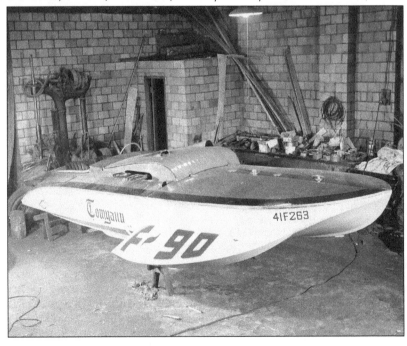

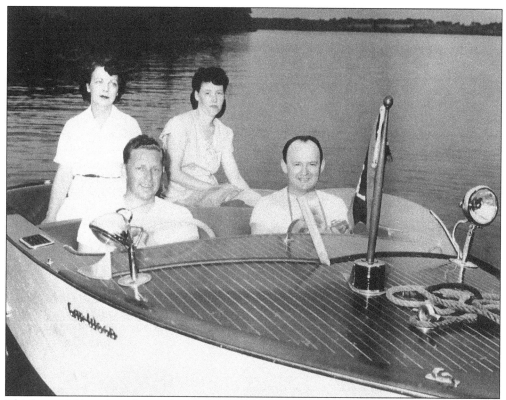

This beautiful boat has plenty of room for the four occupants on an afternoon in 1948. They are, from left to right, (ladies) Ruth Arnett and Charlotte Kieffer; (men) Jerry Arnett and Ted Kieffer. The top-of-the-line Gar Wood craft provided speed and endurance on the lakes. (Courtesy of Kieffer Marine.)

The Antique and Classic Boat Society has over 5,000 members and 40 chapters throughout North America. Portage Lakes held its first-annual antique and classic boat show in 1975. Hours of time and considerable money are invested in preserving boats from past generations. Chris Craft, Lyman, Century, and Gar Wood are among the favorite makes. The event is held the week of the Fourth of July. (Courtesy of the Frank Weaver Jr. collection.)

THE 33RD ANNUAL
PORTAGE LAKES

ANTIQUE BOAT SHOW

JUNE 28th 2008
OLD HARBOR INN &
HOOK, LINE & DRINKERS
— AKRON, OHIO —
FREE ADMISSION
9am - 3pm Rain or Shine
Hosted by North Coast Ohio Chapter
Antique & Classic Boat Society
And
Portage Lakes Historical Society

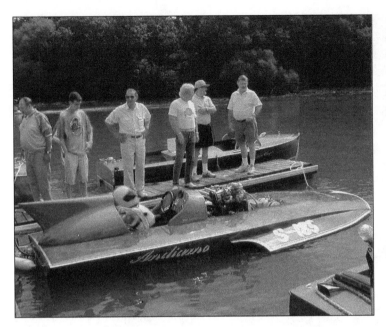

Hydroplane racing was an annual event organized by Doc Prim and Ned Mohrman throughout the 1950s. With more horsepower than is typically allowed on Portage Lakes, this unique craft attracts attention in this early-2000s photograph. Local residents who participated in the popular races included national champion Ron Musson, Jack Force, Donald Norton, Joe Taggert, and Henry Shrake.

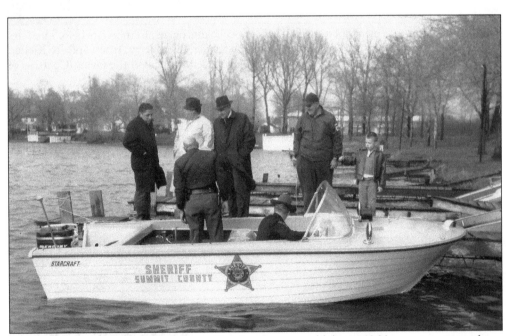

The Summit County sheriff and other officials meet on a cold day in 1966 to review a tragedy on the lakes. Generally thought of as a place of recreation, the waterways can also be dangerous. The three agencies that patrol the state park are Portage Lakes State Park; the Department of Natural Resources, Division of Watercraft; and the Summit County Sheriff's Department. (Courtesy of Portage Lakes State Park.)

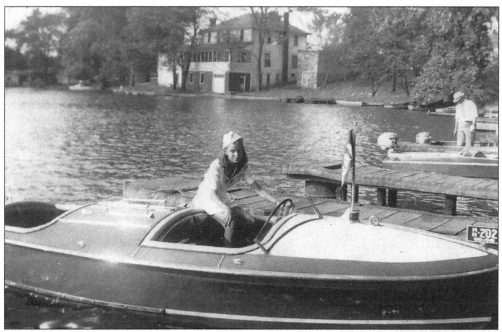

Dot Peale guides the sleek Mullins Sea Eagle *Tin Man* into the dock at Pick's Boat House on the north end of West Reservoir in the 1940s. The handsome galvanized-steel craft was outfitted with an inboard motor and weighed 1,380 pounds. The building in the background is Mellinger's Hotel, now known as the Olde Harbor Inn restaurant. (Courtesy of Dorothy Peale Suit Steele.)

Originally a sailboat, this 1950s vintage vessel sailed the Great Lakes piloted by its owner from the Dayton, Ohio, area. The vessel was converted to a motorboat, and a cabin was added. Bob Boucher, who lived on Gangl Island in Portage Lakes, purchased the hardy boat in 1981. He added smokestacks, and the neighbor kids nicknamed it, appropriately, the "Popeye Boat." (Courtesy of R.C. Norris.)

In modern-day warships, the Navy Whale Liberty Launch is a light, seaworthy boat designed for transport of the ship's crew. The USS *Craig* motor launch whaleboat was assigned to a destroyer in the Pacific in 1967. Transferred to disposal, it was sold in 1981 to R.C. Norris, who drove to San Diego, California, to collect his new purchase. (Courtesy of R.C. Norris.)

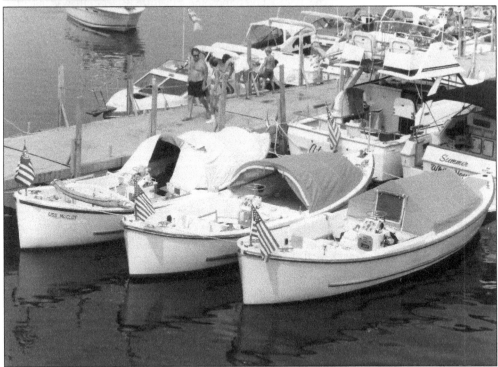

Owners of these Navy whaleboats, often called Liberty Launchers, were Portage Lakes residents who moored their craft for the weekend at Put-In-Bay on South Bass Island. The photograph was taken from a nearby water tower. Captains of the whalers are Kenny Mitchell, Jack Droder, Ralph Leadbetter, and R.C. Norris. (Courtesy of R.C. Norris.)

A canoe glides past lily pads on a sunny afternoon. In the early 1900s, there were dozens of canoe clubs between Summit Lake in Akron and Portage Lakes. Owners of Pick's Boat House on Portage Lakes Drive maintained between 250–300 rental canoes during the peak season. (Courtesy of Brenda Patterson.)

This old dredge was employed to work in the waters of Portage Lakes in the 1960s. Its main objective was to clear and deepen shallow areas of the lakes and channels. The walkway and barrels held pipe used to pump dredged material to various places onshore. Often, finding a place to deposit the spoils was problematic because of the content of the material. (Courtesy of *Akron Beacon Journal*.)

It has been said that Ohio is the birthplace of aviation because of the progress that the Wright brothers made in the area with aircraft. In 1903, the inquisitive young men successfully built an airplane that stayed in the air for over 30 minutes. Today, they would be delighted to see this Piper Super Cub float to a landing on the water in Portage Lakes.

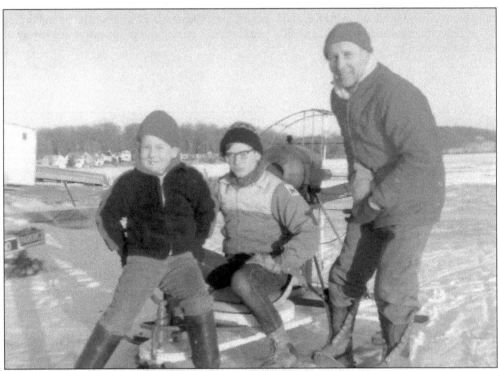

This vehicle looks like a swamp buggy on ice, which is seen on Portage Lakes in the dead of winter. James (left) and Lynn Barnett are aboard the contraption built by Harry Walkner, while their dad, Ora Barnett, supervises the boys. Gliding along on the ice while propelled by the large fan, the craft was a spectacle among the "character" boats on the lakes. (Courtesy of R.C. Norris.)

This 1970 Wooster Hellion, manufactured by Rubbermaid, needed a bit more than just tender loving care when its current owner discovered it in a trash pile. New stringers, floor, and transom were installed, the gelcoat restored, and a 9.9-horsepower Johnson outboard motor added. This little, two-person runabout won second place in its class in the 2003 Portage Lakes Antique Boat Show. (Courtesy of the Doug Hull family.)

Just the right size for a kid, the two-seater Wooster Hellion can absolutely stir up the water. The small novelty boat has now become a collector's item, and if found it often requires serious renovation. In this photograph, young Mark Norris puts the Hellion through its paces. Recently, boat-safety classes and appropriate licenses are required for all drivers of boats on the lakes. (Courtesy of R.C. Norris.)

Selling for $50, with a patent pending in the 1930s, the rubbery bubble boat was promoted. Manufactured in Akron, Ohio, the air-filled tube was pulled by a motorboat. Similar to the popular tube made of vinyl used by boaters today, it was displayed at boat shows throughout the country. It was not a hit with the boating crowd, and the bubble boat was doomed. (Courtesy of R.C. Norris.)

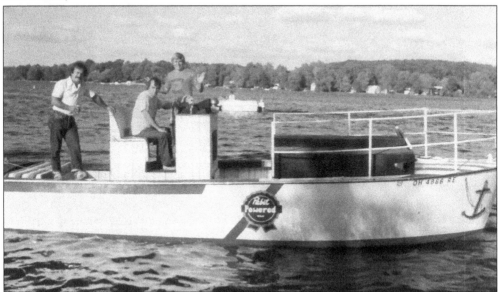

After the 26-foot *Inland Seas Cruiser* sank in Lake Erie, it was salvaged and taken to a farm in Manchester, Ohio. The 1950 or 1952 vintage boat remained dry-docked until 1973, when longtime Portage Lakes residents Jim Krimmer, Andy Pataki, and R.C. Norris (right) purchased the craft. The boat was eventually sold to Andy Pataki, George Kitchen, and "Bosco," who dubbed it *Pabst Blue Ribbon*. (Courtesy of R.C. Norris.)

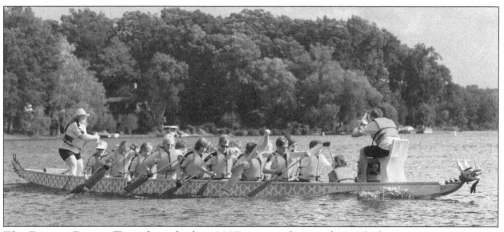

The Dragon Dream Team launched in 2007 is one of more than 150 breast cancer–survivor dragon-boat teams around the world. Members come from all over northeastern Ohio to be part of this special group based at Craftsmen Park on Rex Lake. Inspired by the courage of the dragon and the power of the paddle, the Dragon Dream Team participates in local, regional, and international competitions.

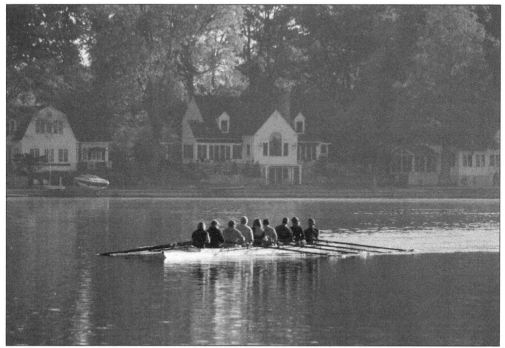

Members of the Portage Lakes Rowing Association (PLRA) practice five days a week from April to November and frequently participate in regional regattas. Founded in 2005, this is the only official rowing club in the Akron/Canton area. Originally based out of the Turkeyfoot Island Club, the organization moved to Craftsmen Park in 2006, and membership grew from a dozen to over 60 rowers. (Courtesy of PLRA.)

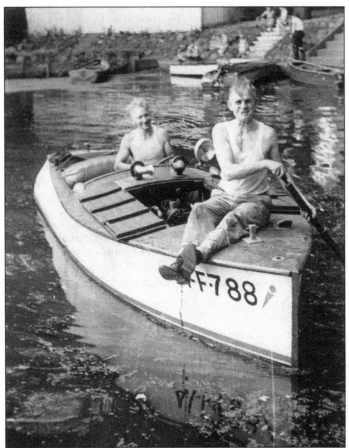

Russ Spencer (behind the wheel) operates one of the many homemade boats on Portage Lakes in 1946. Whether designed for the popular sport of boat racing or merely a pleasure boat for family and friends, all watercraft were required to be registered with the government during the war years. (Courtesy of Bob Ashley.)

Watercraft of all sizes and designs are found on Portage Lakes. Boats with up to 400-horsepower motors are permitted; however, there are several no-wake zones. Electric, rather than gasoline, motors are required on Nimisila Reservoir. Laws are strictly enforced throughout the state park waters. Well-attended fishing tournaments attract contestants from the entire state.

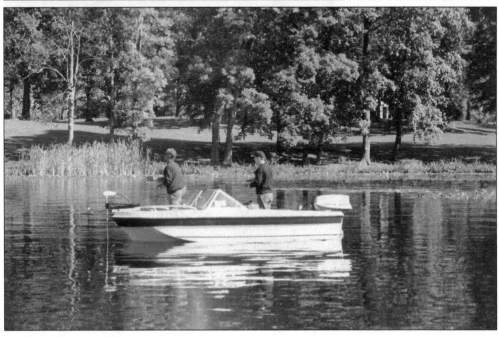

It looks like a car, and it drives like a car, so it must be a car. But this is an Amphicar powered in the water by twin propellers mounted under the rear bumper. It is possible to watch this vehicle motor along on the highway and then drive directly into the water. It was manufactured by the Quandt Group. The appropriate license plate reads, "ABOAT2." (Courtesy of Brenda Patterson.)

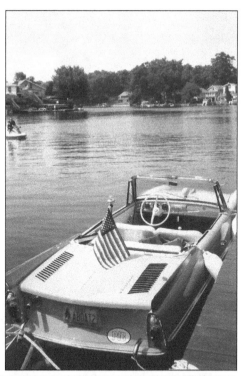

The *Robert C* (41N118) can be seen sitting outside of Dietz's Boat House in 1947 at one of the busiest water intersections on the lakes. During the peak boating season, thousands of watercraft travel between West Reservoir and Turkeyfoot Lake. The narrow waterway under the bridge on Route 619 only allows two boats at a time to pass. (Courtesy of Bob Ashley.)

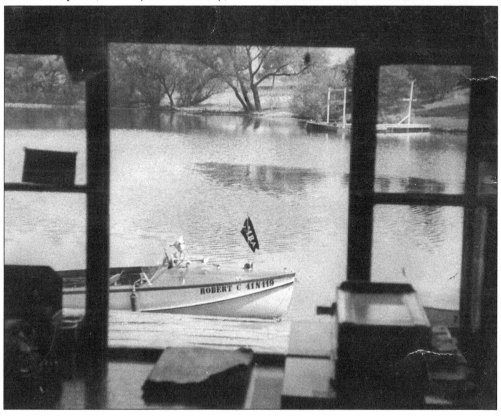

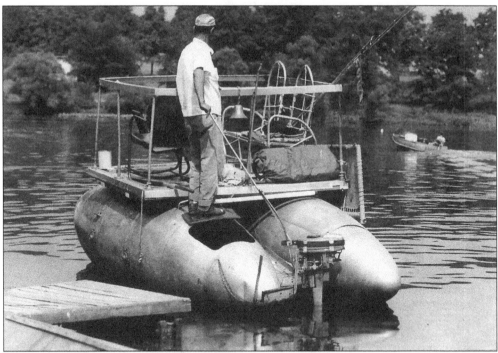

Belly tanks, or drop tanks, were auxiliary tanks attached to the undersides of World War II fighter aircraft. These tanks increased the range of the fighters, enabling them to accompany bombers to their targets. Thousands of these tanks were later sold as surplus and used for a variety of things. In this case, their purpose was to create an early version of a pontoon boat. (Courtesy of R.C. Norris.)

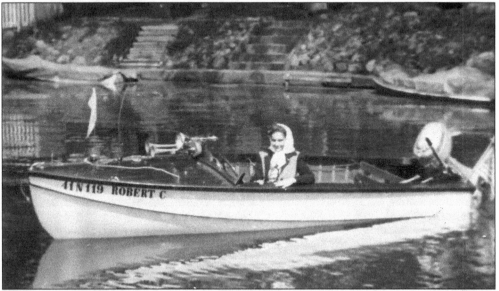

The *Robert C*, decked out with air horns, was a regular in the popular boat races of the day. In 1951, the contests featured both standard motorboats and hydroplanes. A year later, the American Power Boat Association sanctioned the Portage Lakes Regatta, and racers came from throughout the United States and Canada to participate. (Courtesy of Robert Ashley.)

Summit Motor Boat Association was founded in 1936. Treasurer Tom Curly and his wife, Ann, are shown in this 1951 photograph from the club's archives. By 1956, the club was renamed the Akron Yacht Club and eventually leased land from the Infant of Prague Villa Catholic Brothers. The Cottage Grove lake property was cleared of debris in 1969, and within a year volunteers began to build a pavilion. (Courtesy of Akron Yacht Club.)

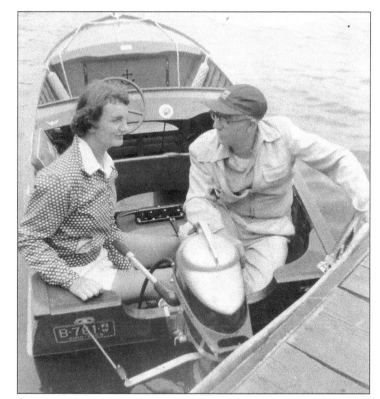

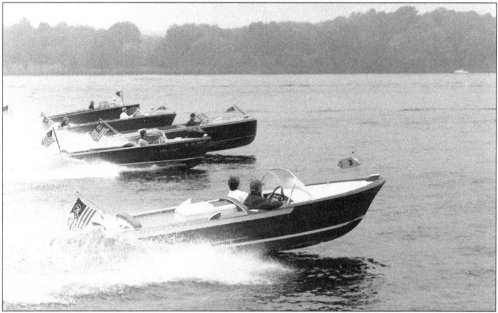

These boats are classics that were manufactured before the popular fiberglass boats of today. The older craft generally belong to proud owners who are willing to spend the necessary time, energy, and dollars required to maintain these jewels. All of these boats appear to be Chris Craft models driven by, from front to back, Les and Marilyn Demaline, Scott Shookman, Gil Maringer, Dr. Benjamin Gill, and John Vorhies. (Courtesy of Bill Hunter.)

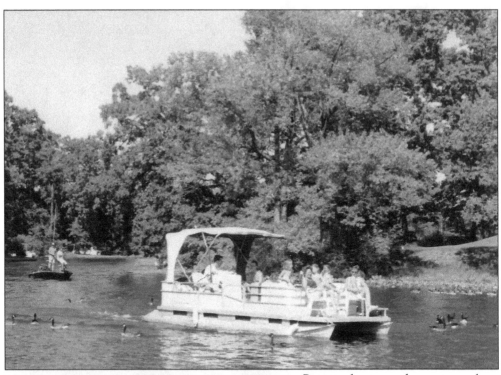

Pontoon boats are the most popular and numerous boats on Portage Lakes. They provide a safe ride for pleasure-seekers, are low-cost for their capacity, and are cheaper to insure than other boats. Pontoon-boat invention in the United States is credited to a farmer who lived on the Horseshoe Chain of Lakes in Minnesota in the 1950s. He started with steel barrels welded together to support a platform.

Sunday mornings are reserved for sailing on Portage Lakes. In the afternoons, powerboats, Jet Skis, and water-skiing will take over, but boaters who enjoy the wind whipping the canvas have the state waters to themselves in the early part of the day. H.A. Bendroth was the first commodore when the South Shore Yacht Club was founded in 1937.

Nine

COMMUNITY AT LARGE

Every progressive community relies on organizations to provide services that benefit its residents. Law enforcement, fire departments, schools, churches, and civic groups provide the foundation upon which society depends. The Portage Lakes area consists of three political entities, each having its own government, schools, and fire department. Yet there are organizations under the umbrella of Portage Lakes in which residents of all three participate.

The Community Church of Portage Lakes began holding worship services in June 1956 at Coventry High School. Pastor Ralph Steese led the newly formed congregation in purchasing seven acres of property on Cormany Road. First, a parsonage was built that served as a center for prayer service, choir practice, and committee meetings. Dedication Day, shown in this photograph, was held on April 3, 1960. (Courtesy of Rose Ann Clark.)

In 1950, the Missouri Lutheran Synod subsidized the launch of a mission congregation in the Portage Lakes area. Rev. Paul E. Kolch was the first pastor at Hope Lutheran Church. Five acres of property was purchased on Portage Lakes Drive, and a new building was dedicated in 1954. Fire claimed much of the structure in 1974, but the congregation rebuilt under the leadership of pastor Hebert Kreiger.

One of the earliest churches in Portage Lakes was Lockwood United Brethren in Christ Church, with its tall steeple and beautiful stained-glass windows. The 60-foot-by-40-foot building cost $2,277 and replaced a facility that had housed both the Lockwood church and the Reformed church. (Courtesy of Portage Lakes Historical Society.)

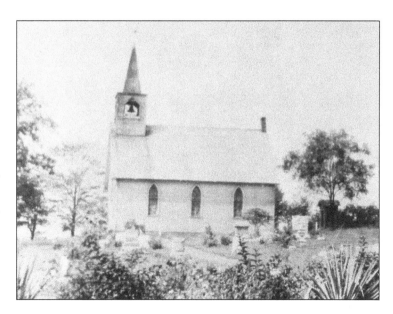

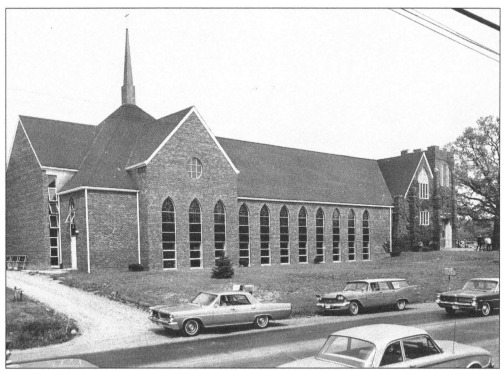

The Lockwood United Methodist Church celebrated its 150th anniversary in 2002. In 1852, the Church of the United Brethren in Christ put up a building behind the "Burying Ground." A new church was constructed in 1882 and was used until 1940, when it was condemned and sold at auction. For two years, worship services were held in Lockwood School while the new church was being built. (Courtesy of Lockwood United Methodist Church.)

The Lockwood United Methodist Church was bursting at the seams, and plans were made to build an educational annex. The addition was completed and dedicated on January 20, 1950. The church continued to grow under the leadership of Rev. Kenneth Hulit, and another building was constructed in 1955 that could house 525 children. (Courtesy of Rose Ann Clark.)

Larger-than-life-size figures on the south side of Killian Road greet travelers during the Christmas season. The scene may look familiar to some readers, as it is the same Nativity that the M. O'Neil Company of Akron displayed at its Main Street store years ago. With the encouragement of employee Shirley Chuchu, the Visual Department of M. O'Neil agreed to sell the large characters to the church. (Courtesy of Cornerstone Free Methodist Church.)

St. Francis de Sales was born in 1567 and is the patron saint of writers. He was a priest who became bishop of Geneva and was canonized by Pope Alexander VII. Local St. Francis de Sales parish members who assisted in the early days of the church included Ralph Maglione, George Wepler, Howard Riley, John Gless, Stephen Drescher, and Bernard Young. The Ladies Guild met at Sandy Beach Park Pavilion in 1948.

Rev. Francis Diederich was born in Cleveland, Ohio, on July 23, 1904. After being ordained in 1931, he was appointed to St. Paul's Parish in Akron, Ohio. As the community of Portage Lakes grew, many Catholics traveled from the lakes to St. Paul's in South Akron. In May 1948, the new St. Francis de Sales Parish, servicing approximately 42 square miles, was established with Reverend Diederich as the pastor.

A piece of property on Manchester Road with a house and several barns on eight acres of land were purchased for $17,000 in 1948. It was bought for the purpose of establishing a location in the lakes for St. Francis de Sales Parish. The house was remodeled and completed for residency the next year. Eventually, a school and a convent were added. Ground was broken for a new church in 1969.

St. Francis de Sales School opened its doors to children in 1950. It has grown from four rooms with 174 children to over 18 classrooms at this time. The first church occupied the third floor of the school building. Nestled in the heart of the Portage Lakes region, it attracts students from Coventry, Green, Manchester, Barberton, and Springfield. (Courtesy of St. Francis de Sales School.)

Schoolgirls wave to the boy in the back window of the Coventry school bus in 1944. The district was proud of its progressive busing program that transported students to and from school for 4¢ daily. This bus is leaving the intersection of Portage Lakes Drive and North Turkeyfoot Road, where the Grandview Inn, once known as the Silver Bell Tavern, is located. (Courtesy of Dorothy Peale Suit Steele.)

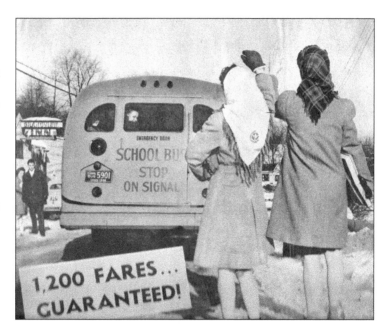

This image shows Mrs. Hoff's second-grade class at Turkeyfoot School in 1954. They are (last names only), from left to right, (first row) Stern, Wood, Streets, Wheeler, Tanner, Osburn, Nelson, and Schultz; (second row) Swartz, O'Donnel, Zagray, VanPelt, Smith, Prine, Skinner, and Snyder; (third row) McDaniel, Wayland, Swanson, Schroder, Warner, Patterson, and Trent; (fourth row) Russel, Perry, Scheu, Umbright, and Powell. (Courtesy of Pam Wayland.)

High-stepping Coventry High School majorettes led the marching band with enthusiasm in 1946. From left to right they are (first row) Tootsie Zufal, Lois Junker, and Dot Bower; (second row) Marlene Feist, Dot Peale, and Jean Hagenbush. (Courtesy of Dorothy Peale Suit Steele.)

The Coventry High School Band was small but mighty in 1946, and it marched with pride under the direction of Ralph Herron. Coventry was not a wealthy district, but it did have a high school building and a marching band. There was no high school in nearby Franklin Township, and Manchester School District secondary students often attended Coventry High School. (Courtesy of Dorothy Peale Suit Steele.)

At 97 years of age, Mae Hinman Packan still delights in talking with former Coventry High School students. She began her teaching career in 1935 and spent 43 years with the local school district. She credits principal Bob Erwine, who later became superintendent, and band director Ralph Herron with structuring an educational environment that was healthy and successful. In her words, "Coventry was Camelot."

Coventry Local School District purchased the former Jackie Lee's entertainment center with a loan of $4 million from the State of Ohio in 1993. Vincent and Jackie Lee Tisci had opened the nightclub and sports center in 1984 on the site of the former Maddox Furniture Store. Superintendent Dr. Gerald Wargo promoted purchasing the bankrupt property for the new Coventry High School.

The Portage Lakes Kiwanis Tower at 399 Portage Lakes Drive was completed in 1979. It was one of the first subsidized senior citizens apartment buildings in southern Summit County. The federal Housing and Urban Development program (HUD) was the mortgagee, and the Lakes Senior Housing Corporation was the mortgagor. The local Kiwanis Club was instrumental in causing the project to move forward.

Since the early 1950s, Portage Lakes Kiwanis volunteers have been delivering gifts to children in the area on Christmas Eve. Parents drop off their gifts earlier in the month, and some 50 well-outfitted Santas visit excited children via sleighs towed by motor vehicles. The Kiwanis organization continues to give back to the community through a variety of projects. (Courtesy of Glen Sheets.)

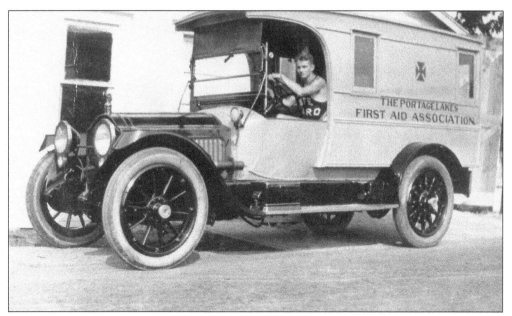

The first emergency vehicle available to transport the ill or injured to the hospital was the property of the Portage Lakes First Aid Association. Laws required that a portion of the taxes paid to the county by saloons and taverns come back to the community. Because of the many liquor establishments, Coventry Township was able to build a fire station with the rebate money. (Courtesy of Portage Lakes Historical Society.)

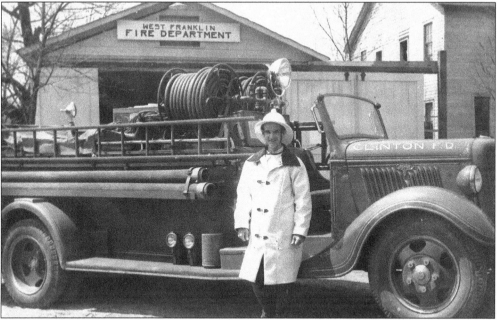

The New Franklin Fire Department has 27 square miles under its jurisdiction. In 1942, it was still a volunteer department, and Wilfred Ross was station chief of the West Franklin Fire Station, later known as Clinton Station I. It was not until the 1960s, when Harry Harget was chief, that the Franklin Township Fire Department become fully manned. (Courtesy of New Franklin Fire Department.)

The Green Fire Station was located in Greensburg and staffed by volunteers who were paid $1 per year. Johnny Rumph (left), Chief Marion Baab (center), and Dale Brumbaugh pose here in the mid-1950s. These men were employed elsewhere, but when the fire siren blew all dropped what they were doing or crawled out of a warm bed to go and fight a blaze. (Courtesy of City of Green Fire Department.)

Fire departments throughout the country must be prepared for water rescue. However, because of the abundance of lakes, New Franklin, Coventry, and the Green Fire Departments must train and be ready for any water emergencies. The New Franklin squad is appropriately outfitted and preparing to go into the water. (Courtesy of New Franklin Fire Department.)

Sons occasionally follow in their fathers' footsteps, and in the Calderone family that is a truism. From left to right, Dave Calderone is the fire chief in Coventry Township; Mickele Calderone was a fireman for 38 years, 28 of those as fire chief; and Robert Calderone is the fire chief in the city of Green. (Courtesy of Dave Calderone.)

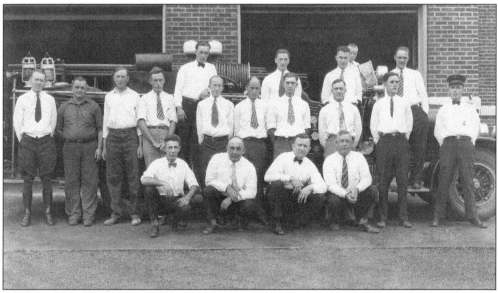

Local residents who manned the Coventry Fire Department in 1930 stand in front of the engine house. From left to right they are (first row) C. Esch, M. Peterson, R. Frantz, and H. Cormany; (second row) P. Scherbarth, F. Walters, F. Wagoner, J. Murray, A. Herman, P. Sibley, R. Warner, B. Gruver, H. Wellock, C. Wellock; (third row) G. McEwen, R. Smith, F. Morris, and R. Binkey. (Courtesy of Coventry Fire Department.)

Purple martins are the largest member of the swallow family, and between 5,000 and 10,000 of these birds roost at Nimisila Reservoir during the month of August. They consume their weight in flying insects daily and are appreciated in the lakes area. Winters are spent in South America, with the birds returning to nesting regions in North America in the spring. (Portage Lakes Purple Martin Association.)

Members of the organization band birds, clean and repair martin houses, feed birds during inclement weather, monitor sites, and keep records. Support comes from the Ohio Division of Natural Resources, Portage Lakes State Park, and numerous volunteer birders in the area. Each fall, over 400 synthetic-gourd houses must be taken down, cleaned, and stored for the winter. (Portage Lakes Purple Martin Association.)

Kenneth Lot Nichols retired from the *Akron Beacon Journal* in 1981 after 50 years in the newspaper business. He was the author of two books, *All About Town* and *Yesterday's Akron*. Nichols and his wife, Catherine, lived on Turkeyfoot Island, and he wrote numerous articles about his beloved island home. In 1987, he died at the age of 75, leaving a legacy of entertaining tales. (Courtesy of *Akron Beacon Journal*.)

In 1956, the Goodyear Boating and Yachting Association moved to Cottage Grove Lake property leased from the Interval Brotherhood Home. The club is no longer affiliated with Goodyear Tire and Rubber Company but has retained the GBYA name throughout the years. Past commodores pictured here are, from left to right, Graydon Poling (1965), Jim Gillispie (1963–1964), Charles Anderson (1962), Warren Adkins (1960), and K.C. Sommerville (1955). (Courtesy of Goodyear Boating and Yachting Association.)

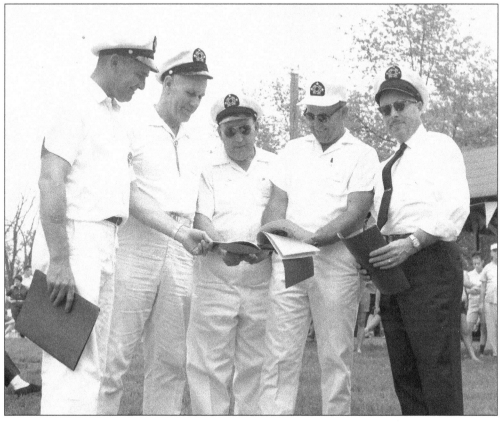

The Antique and Classic Boat Society has over 5,000 members and 40 chapters throughout North America. The North Coast Ohio Chapter sponsors boat shows, workshops, and activities for antique and classic boat enthusiasts. In 1975, Portage Lakes held the first of 36 annual boat shows. These boats are assembled at the Olde Harbor Inn on West Reservoir for judging and viewing by the public. (Courtesy of Don Emery.)

In 1776, Thomas Hutchins surveyed the Western Reserve and provided its financial investors, the Connecticut Land Company, with a map. The land had been divided into 129 townships. Some land was more usable than others; therefore, the new owners received additional property in equalizing townships. Coventry, Portage, and Springfield Townships were designated as equalizing. Here, members of the Portage Lakes Historical Society surround a commemorative disk celebrating Coventry Township's bicentennial. (Courtesy of Debbie Hensley.)

EPILOGUE

Chances are there are many reading this book who still live in Portage Lakes. They love where they live and cannot think of anywhere else they would be as happy living out their lives. There are probably more people who have moved away and have a nostalgic attachment to "the lakes." That is where they grew up, went to school, met their spouses, still have friends, and come back often to visit.

All of these people, when asked where they are from, will say Portage Lakes—not Coventry, Franklin, or Green. They identify with a community, not a city, township, or village. They are attached to the lakes as a community. That attachment is what sets Portage Lakes apart from so many other lakes communities.

There are thousands of lakes in the country, and thousands of communities surrounding those lakes, but the emotional attachment we have for our lakes community sets us apart from all the rest.

Another attribute we possess as "Lakers" is character. Reading this book gives one a look at some of the people who have made Portage Lakes such a special place to live. There are those people who accomplish much in life because they are not afraid to try something new, who venture out and do something, build something, or say something to make a difference. We have been blessed through all the eras of our history to have more than our share of these individuals. These people attract others, and out of those attractions a community is built of people who make things happen.

The first settlers made farms from forests, then waterways to move goods, and finally roads to move about. Land speculators sold lots to those who could afford cottages and vacation homes. These were often people of means. In the tough times, some of this property went to those who made homes from cottages and stayed year-round. They all lived next door to each other and all got along because they had a love and affection for the water and life away from the city.

After World War II, there was a housing shortage, and some returning vets moved into vacant cottages while others built permanent homes. From all of this came a community like no other: rich, poor, banker, businessman, and laborer living side by side. They were raising families and learning to get along. They built schools, sports teams, the PLAY Center, community camps, and even a YMCA. Their children were fortunate to live in what most American families would call vacationland.

There are those who say the lakes have changed, that the old characters are gone and the affluent have taken over—at least on the lake frontage. Yet, as homes throughout the community become available, new owners want the opportunity to live and experience everything that Portage Lakes has to offer.

In the future, the era we find ourselves in now will be looked at as a transition period. We will continue to evolve into another era, but we will always be from Portage Lakes no matter where we find ourselves.

After all, there is no place like it anywhere.

—Walt Stashkiw

CPSIA information can be obtained
at www.ICGtesting.com
Printed in the USA
LVHW060152010221
677990LV00007B/144

9 781531 659493